Carving Religious Motifs in Wood

E. J. Tangerman

D0865570

S Sterling Publishing Co., Inc. New York

Oak Tree Press Co., Ltd London & Sydney

About the Author

E. J. Tangerman has been whittling and woodcarving for over 50 years, winning numerous awards and exhibiting his work in many one-man shows in and around New York City. In addition, he has taught, judged international shows, and written magazine articles and books, including "Whittling and Wood-carving," long considered the basic text in the field. Mr. Tangerman was, until recently, vice-president of the National Wood Carvers Association.

Figures 1 and 36–40 are courtesy of the German Information Center, New York, N.Y.

Library of Congress Cataloging in Publication Data

Tangerman, Elmer John, 1907–
 Carving religious motifs in wood.

 Includes index.
 1. Wood-carving—Technique. 2. Christian
art and symbolism. 3. Religious articles.
I. Title.
TT199.7.T34 731.4'62 80-52321
ISBN 0-8069-8938-6 (pbk.)

Oak Tree ISBN 7061-2726-9

Contents

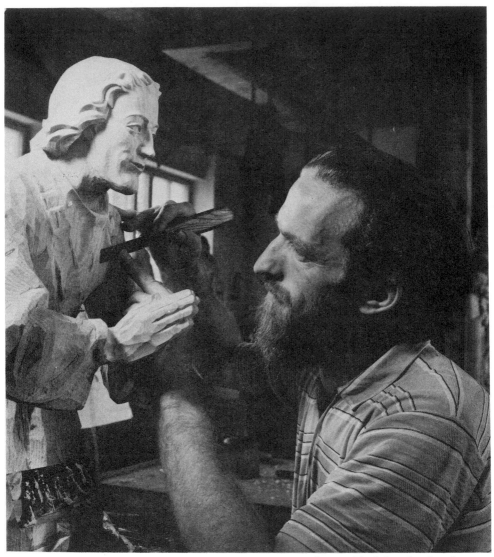

Fig. 1. A woodcarver in Oberammergau at work on a Nativity shepherd.

The "Why" of This Book

SINCE TIME IMMEMORIAL, man has carved images of his gods, and he is still carving them. In fact, in primitive areas a very high percentage of the carving is related to religion—some of it Christian, as locally interpreted, some of it depicting other beliefs, and some of it recalling the ancient gods.

Until recently, almost all liturgical carving of any consequence done in the United States was produced by carvers trained in Europe. The Protestant Reformation and the rise of Puritanism in England not only resulted in the destruction or defacement of many fine woodcarvings, but also eliminated the demand for them and for literature in English describing how to make them. In recent years, however, clerics have been seeking more and more carvings for their edifices, while lay individuals have become increasingly aware of carved religious symbols for their homes. Also, the tremendous increase in travel has developed our appreciation of the beauty and decorative quality of religious carvings of other cultures as well. As a result, many American amateurs and professionals are making such carvings, ranging from highly precise copies of traditional forms to quite modern ones.

I have included, in this volume, many of the traditional forms, plus some typically modern ones, as well as some outstanding examples from other cultures. I have tried to include as many as possible that can be carved by amateurs with relatively few tools, and have tried to present them in a graded sequence. I have included information on tools, sharpening and woods, so that the book is complete in itself. The many two-view patterns can readily be enlarged, reduced or adapted to meet a particular need. Included also is information on textures and finishes, as well as hints on making the pieces I have carved. There are also examples of the work of noted carvers of the past and the present. I hope you will find these projects as interesting and rewarding as I did.

E. J. Tangerman

CHAPTER I

What You Need to Know About Tools

What's available and what to start with

FOR SMALL RELIGIOUS AND MYTHICAL FIGURES and for details on panels, I automatically use the knife. This is not the case, however, with foreign carvers. In Europe, carvers tend to use chisels whenever possible, even when doing essentially knife work, by holding a tool, such as a skew chisel, by the blade. In Africa, northwestern America, Italy (and in ancient Egypt), the adz is the basic tool. Indeed, some carvers in these areas have several adzes with blades ranging from flat to semicircular in cross-section, or even handles that can be fitted with interchangeable blades. The adz does have the advantage of requiring only one hand even for heavy cutting, because it combines the chisel and the mallet, just as an axe may be said to do.

The tools you will need will depend upon the carvings you plan to make. As a guide, I have indicated throughout this book the tools I used. It is not essential, at least initially, to have a wide range of tools; they should be selected to meet your particular needs (and your pocketbook) as you go along. A few basic shapes will do for starters, and if you're going to concentrate on small figures, the knife alone will suffice.

A pocketknife is the most convenient tool because it is compact, versatile and can be closed for carrying. One with two blades, or at most three, is best, and I have always preferred the penknife to the jackknife because the blades are smaller and shorter. For most work, there is no need to use a blade longer than 1½ in (3.8 cm). Blades should include at least one with a longish point; a good combination of shapes is a B-clip, a pen and a spear. Blades should be carbon-steel rather than stainless, because carbon-steel holds an edge longer, although it does require occasional oiling to prevent its rusting in the pocket from sweat. The handle should be comfortable to hold, with no projections like corkscrews.

Carving tools basically consist of chisels in wide variety. The basic difference between a knife and a chisel is that the cutting edge of a knife is at a right angle to the length of handle, so that the cutting force is lateral, while

in a chisel the cutting edge is at the end, so the force is longitudinal. This is far more important than it may seem, because many knife cuts are similar to those you make when peeling a potato: the thumb positions the blade, and the cutting force is applied by clenching the fist. Most of the important cutting with the knife is done with the hand muscles, so it is under control.

On the other hand, the cutting pressure on a chisel is applied either by pushing with the muscles of the arm or by striking the end of the handle with a mallet, hammer, club, or even the heel of the hand, so control may be less precise, although the cutting force is greater. As a matter of fact, there is a paradox in the use of the cutting chisel with the hands alone: the hand gripping the chisel is pushing it into the work, while the hand guiding it actually holds it back at the same time! This is because a chisel, if simply pushed into the wood, may dig too deep, cut too far, or even split the wood. As in any other operation, the greater efficiency of the chisel is countered by a greater danger of error.

The woodcarver's chisel is essentially lighter in weight and more compact than a carpenter's chisel of the same size. Also, the flat chisel in woodcarving is called a *firmer*, and differs from the carpenter's chisel in that it is sharpened from both sides to reduce the likelihood of its digging in. The gouges range in sweep (circle diameter) from almost flat to U-shaped, and are available in a very wide range of sizes for each sweep. Also, the shanks may be straight or bent in long or short curves, even bent backwards, to get into tight spots, and the shank may be thinned down for clearance as well, in which case the tool is called a *spade* or *fishtail*. (This is obviously necessary with very wide tools, or the tang—the end opposite the cutting edge—could never enter the handle.) These differences are best shown in the accompanying sketches (Fig. 3).

Gouges and firmers are available in English measure from $\frac{1}{16}$ to $\frac{3}{8}$ in (1.6 to 9.6 mm), in increments up to 1 in (25.4 mm) in eighths, and up to 2½ in (6.3 cm) or so in larger gradations. Tools made to metric measure are in widths of 1, 2, 3, 5, 6, 7, 8, 10, 12, 16, 20, 25, 30, 35 mm (1 mm = 0.037 in). The gouges may vary from almost flat to U-shaped, as I said earlier, and these sweeps are designated by numbers in some systems of identification. The smallest and deepest gouge, usually $\frac{1}{16}$ in (1.6 mm) across, is called a *veiner*, because it is used in veining, and a $\frac{1}{8}$-in (3.2-mm) gouge is called a *fluter*, because of its use. There is also a *V-tool*, which, in effect, is a double firmer with the edges meeting in a vee; a *macaroni*, which is a 3-sided rectangular tool, and a *fluteroni*, which is similar but has arcuate

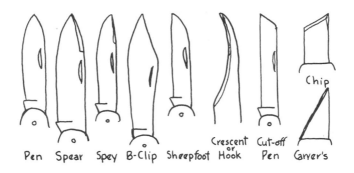

Pen Spear Spey B-Clip Sheepfoot Crescent or Hook Cut-off Pen Carver's

Fig. 2. Knife blades.

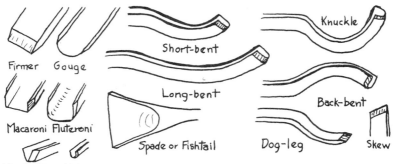

Firmer Gouge Short-bent Knuckle

Macaroni Fluteroni Long-bent Back-bent

V or Parting Veiner Spade or Fishtail Dog-leg Skew

Fig. 3. Chisel shapes.

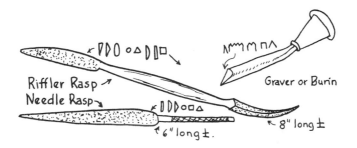

Riffler Rasp
Needle Rasp
6" long ±
Graver or Burin
8" long ±

Fig. 4. Rasps and burin.

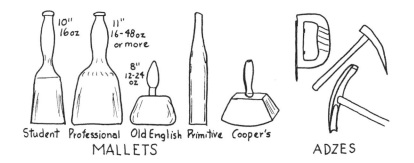

Fig. 5. Mallets and adzes.

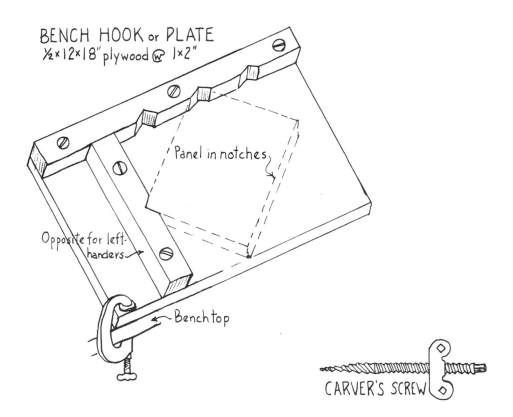

Fig. 6. Two methods of securing your carving.

corners. The latter two are quite uncommon these days, and rather difficult to keep sharp, as is the V-tool. Many of the other shapes also once had special names, but they are no longer used to any degree in the United States.

Mallets also come in many shapes and sizes. The traditional one is like an old-fashioned wooden potato masher and has the virtue that it is not necessary to strike the tool precisely square with it. It comes in many weights, ranging from a few ounces to 6 lb or more. The traditional material of mallets is a hard wood like cocobola or lignum vitae, or maple in cheaper versions, but very good ones are now made with a plastic casing over the wood to provide more "bounce" and reduce shock and noise. Homemade variations include cylindrical heads of lead or babbit metal, or even sections of old rubber-covered wringer rolls put on a dowel rod. Another form is the cooper's mallet, essentially a block with sloping faces (see Fig. 5). In the Far East and in less privileged countries, the carvers simply use small clubs.

Various authorities suggest various combinations of tools, but these usually boil down to a firmer or two, three or four gouges of varying sweep and size, a veiner and a V-tool, plus a good carver's knife. As you discover what kind of carving you want to do, these basic tools can be supplemented with others. The advantage of a variety of tools is that some cuts can be made smoothly and of consistent shape with a single pass of the tool; the disadvantage is that you have that many more tools to maintain and must spend that much more time selecting the right one for each cut.

In addition to the basic tools, there are many auxiliaries, some of which any home worker already has, such as rip and crosscut saws, coping saw, rasps, sandpaper and whetstones. Also needed will be some form of holding device (if the work is intermediate in size). I use a machinist's vise and a larger carpenter's vise, plus two or three clamps of different sizes. A traditional holding device is the carver's screw, which is simply a longish screw passed through a hole in the bench or table into the base of the workpiece, and with a wingnut on the opposite end so the piece can be held securely, yet can be rotated easily as the cutting progresses. You can also get a variety of vises with universal-joint tops.

It is obvious from this that you also need a good workbench or a pedestal with weight added (a big rock) at the bottom, and possibly with a rotating top like a lazy Susan. Professionals tend to have bench or pedestal high enough so that they can stand while working. I prefer to sit down whenever possible; therefore I like to use a sturdy card table with two legs folded so it can rest at a slight slope on the arms of my chair beside the fireplace. Thus

Fig. 7. Tools can be home-made. This aluminum chuck handle, used with blades ground from old hacksaw blades, was made by John Phillip, of Whittier, California.

I can dispose of shavings and mistakes without much effort. If, however, you plan to do a lot of sanding or rasping, or power cutting, you'd best have a separate room away from the house proper and which you can close off.

If you are carving panels, particularly small ones, a bench plate may be an ideal solution. This is simply a flat piece of plywood, bigger than the carving, with stop boards screwed to the back and one side and possibly notched so the carving can be set into it at an angle (see Fig. 6). This is held to a bench or table with a clamp. It is even easier, if there is waste wood on the panel and it is not too thick, simply to nail it to the bench through the waste wood. The important thing is to be certain the work doesn't move unless you want it to. Large panels and heroic sculptures present no holding problems; they are usually big enough that your mallet blows will not move them.

Some pointers on sharpening

SHARPENING IS A NECESSARY EVIL. It is boring and takes a great deal of time to do properly by hand. Sharp tools, however, cut faster, more accurately and more safely than dull ones, and they give a smoother finish that will not require sanding. (Indeed, the finish may be roughened by it and the sharp

cut lines blurred.) Hence, many woodcarvers have now worked out methods of buffing the edges of tools by machine.

There are actually four operations in sharpening: grinding, whetting, honing, and stropping. Grinding is rarely needed after the initial edge is put on a tool, unless the edge is nicked or broken or extensive use has blunted the cutting angle. Most tools are ground when received anyway, and grinding must be done very carefully to prevent burning the edge.

Whetting and honing are progressively finer grinding operations, usually done by hand—whetting on a somewhat coarse stone, honing on a finer-grained one. Formerly, these were cut from natural stone: the whetstone from Washita, which is yellowish or greyish, and the hone from Arkansas, a white, very hard and uniform fine-grit stone. (Arkansas is also the material used for "slips," the small, shaped stones used for cleaning the burr from the inside of veiners, gouges and V-tools as well as for general honing when you're up a tree or on a scaffolding.) There are now synthetic whetstones

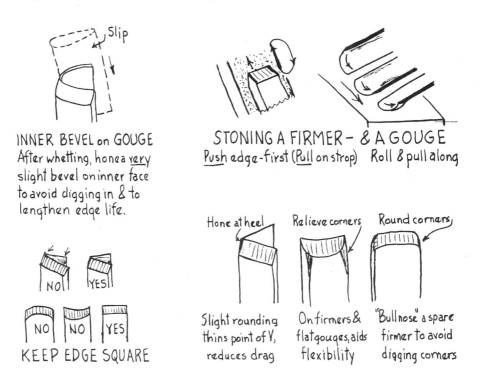

INNER BEVEL on GOUGE
After whetting, hone a very slight bevel on inner face to avoid digging in & to lengthen edge life.

KEEP EDGE SQUARE

STONING A FIRMER – & A GOUGE
Push edge-first (Pull on strop) Roll & pull along

Hone at heel Relieve corners Round corners

Slight rounding thins point of V, reduces drag

On firmers & flat gouges, aids flexibility

"Bullnose" a spare firmer to avoid digging corners

Fig. 8. A few sharpening tricks.

and hones available; in fact, you can obtain a combination with coarse grit on one side and fine grit on the other. There are also "stones" made by embedding grit in rubber or plastic. On all stones, the blade is held at a slight angle and pushed edge-forward along the stone. As you gain experience this push can become a loop or even a figure-8, with pressure applied on the forward motion and relaxed on the return.

Stropping is done on a leather strap or strop, usually glued to a piece of board having a handle. Professionals use a double strop, one side with a coarse leather surface impregnated with crocus powder in oil, the second with smooth leather impregnated with oil alone. Stropping, in contrast to the other sharpening operations, is done by *pulling* the edge toward you rather than pushing. Its primary function is to align the microscopic teeth of the feather edge of the blade. (If you have watched a barber strop a straight razor, you'll get the idea, and see the fast method.) You can learn to pull a knife toward you on the strop, then roll it over the *heel*, or back of the blade, and strop in the opposite direction. (With chisels, this cannot be done, of course.)

The theory of sharpening is to obtain an edge that has about a 15° included angle on a knife or gouge, and 15° each side of center on a firmer. You'll find with experience that a slightly greater angle is better and longer lasting on very hard woods, ivory and bone, and possibly a slightly lesser angle is more efficient on soft woods like pine and basswood. However, particularly on soft woods, it is important to keep the blade as sharp as a razor—literally. Many problems with digging, roughness, tearing and splitting are the result of dull tools. There are three simple tests for sharpness. The first is to hold a piece of newspaper between your fingertips and draw the edge across it; the tool should cut. The second is to draw the edge across the tip of your thumbnail; it should tend to "stick"—cut—rather than simply slide across. The third is to make a diagonal or corner cut on a piece of soft wood; the blade should cut smoothly and evenly—even across grain.

The gouge is harder to sharpen than a flat blade, because it must be rotated while passing over the stone. The safest way to do this is to move the gouge sidewise along the stone, rolling it as you go. You can eventually learn to push it like a firmer or knife, but this is tricky and usually results in flat spots on the edge for a beginner. Also, there is the danger in sharpening any gouge that you will rotate the tool too far, resulting in rounded corners or an arcuate edge. Tests are similar to those for a flat blade, but in addition there is one called the "line of light"—if you sight at the edge and can see a

reflected line, there is a flat spot there which must be honed out. Also, the conventional stone will not reach the inside of a gouge, so a burr will form there. This must be removed by stroking all along the inner edge with a slip. Actually, the slip should form a tiny bevel there of about 15°—giving the included angle of 30° you have on a firmer. The inner bevel should be less than a quarter of the length of the outer one, but it will make a major difference in the smoothness of cutting, particularly when the gouge is inverted (shaping a mound rather than cutting a groove) and will lengthen edge life as well. A gouge can be stropped on the inner bevel with a folded piece of leather to get the effect of the flat strop, which is used on the outside.

The V-tool is much harder to sharpen than the others because there is inevitably a thicker spot at the base of the V. Some of this can be removed by inner beveling if your slip is sharp enough, but an easier way is to round the outer end of the V slightly, as shown in Figure 8. Also, a V can be cut in the strop for honing the outer surfaces simultaneously. Under no circumstances should you allow a projection to form at the junction of the V; it should be square with the cutting edges.

There are of course many tricks in sharpening; I've described a few. Also, by buffing rather than stropping, many of the problems with slips will be avoided, although old-time professionals tend to scoff at such modern ideas. They hone or strop the blade *very frequently,* and usually absentmindedly, between cuts, while they're taking that necessary overall look, particularly when the carving is nearing completion. Some professionals hone and strop a tool each time they use it, feeling that the ultra-sharpness is lost when the tool lies dormant. In any case, it is vital to protect tool edges when they're stored or carried about. Canvas or leather rolls with pockets are now available for carrying up to about 20 tools, plus hones, slips, strops and rifflers.

CHAPTER II

What Wood Is Best?

**Some woods are traditional in some countries,
but wood should suit subject**

WHEN WE SPEAK OF RELIGIOUS CARVING, we almost automatically think exclusively of Christian-church carving, particularly as developed in Europe. The kinds of wood used traditionally are similarly limited to the woods familiar to England and northern Europe. In recent years, however, our knowledge and appreciation of the religious carving of other parts of the world has made us realize that carvers have used whatever suitable woods were available. Among "primitive" carvers ("primitive" does *not* mean crude, but simply that the style was not influenced by European ideas and traditions), certain woods were felt to have particular religious significance, and these were selected for idols and images whenever possible. Indeed, in some instances, a particular wood may have been restricted for such use.

In Egypt, sycamore and cedar were the woods carved for temples; among the Greeks and Romans, it was cedar; in Hindustan, sandalwood. Most Gothic carving was in oak; Gibbons preferred lime or pear for the intricate detail of his floral swags; the Swiss used satinwood; the Germans, apple or pear. Oak was the preferred wood for exterior carving in Europe because it resisted wear better than others (particularly the English oak, which is finer grained and somewhat between our white and red oaks in characteristics). Oak was also carved in America, but has never been as popular here because our white oak is somewhat coarse-grained, our red oak, bad. Basswood, which was once called "bee tree" here, and is akin to European lime and linden, has always been a workhorse wood for figures that were to be polychromed and gilded; it is tractable to carve and durable when painted. It was, and is, usually assembled by gluing and laminating. In England, deal—fir or pine— was the familiar wood to be painted.

In English churches, walnut, pear, chestnut and cedar were also used on occasion. Cherry came in after 1675. The English "Age of Walnut" began with William and Mary (1688–1702). Mahogany was brought to England

in 1597 by Raleigh, as repair timbers for his ships, but it didn't become a familiar wood in Europe until after 1720, when it practically replaced walnut. Part of the reason for this is that English walnut has a great deal of "figure" or grain marking; the Italian walnut, although coarser, is better. Neither, however, compares with our black walnut as a carving wood, or even for structural purposes.

Incidentally, inlay is relatively uncommon in votive carving, except for altar crosses, pendants and other small pieces. I have seen ivory and shell inlay in altars in areas where they are used in carving, and occasional wood inlay in church furniture and altarpieces. It is, of course, possible to substitute

Figs. 9–10. Two heroic Japanese carvings: On the left, a caricature of a disciple of Buddha known for his love of saki (rice wine). It stands outside the Tadaiji Temple at Nara. It has cloth covering the head and shoulders, but the paint has become so weather-worn that the wood laminations can be seen. On the right is one of two monkey figures guarding a Shinto shrine in Tokyo. It is a combination of painted and gilded wood with appliquéd designs.

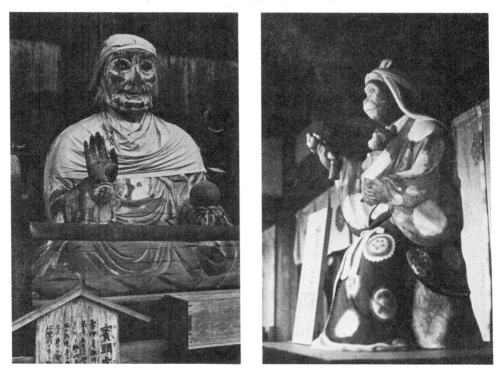

abalone for paua shell, or holly for ivory, or brass for gold, or steel for silver. I saw a church in New Jersey some years ago, with a black congregation, which had saints with robes of stainless steel and the visible body parts— arms, head and feet—carved in walnut. American Indian churches have Nativity scenes in darker woods and figures that are Indian in countenance; other races make similar changes. The material is not critical, but the thought behind it is.

Larger in-the-round figures are often not a single piece of wood, but are built up, particularly if they are to be painted. Also, if they are built up, the wood cost is less, the carving may have more inherent strength, and there is less chance of checking and cracking with changes in humidity. Obviously, much modern wood is most readily available in planks that have been kiln-dried, often limited to a 2-in (5-cm) thickness (about 1¾ in [4.5 cm] after planing). It is advisable, if a block is to be built up, to estimate the approximate shape of each lamination and to saw it to shape before assembly. The interior can also be hollowed to inhibit checking—something that old-time carvers often obtained by splitting and hollowing the finished carving, then gluing it back together!

Assemblies can be made with traditional hot glue or any of the modern glues, but you must be certain that mating surfaces really mate and you must clamp the assembly while the glue sets, otherwise you may have unsightly cracks and the piece will have a tendency to split during carving. Arms and legs can be similarly built up (and left solid), with the grain of the wood running the long way of the element as nearly as possible. Many professional carvers carve the parts of a figure almost completely before attaching arms and legs or placing them on a base; then only fairing-in of the mating surfaces is required. When arms are applied at right angles, for example, it is advisable to supplement the glue with dowels or nails driven deep enough so you won't hit them with tools when finishing.

For large panels, side-by-side assembly of planks is often necessary, again because wide widths are no longer readily available. In this case, the mating edges should be planed square and the gluing supplemented with dowels. There are jigs available for guiding a drill for such doweling; without them you must be very accurate in measuring and drilling. (I find a drillpress advisable to assure squareness.) For panels, clamping while the glue sets is essential. If you don't have clamps wide enough to span, set the glued assembly (over a piece of paper so it doesn't stick to the surface) on a table against a stop board and put pressure on the joint with wedges on the far side.

CHAPTER III

How to Enlarge a Design

Choose the method easiest for you, and for the subject

IN LITURGICAL CARVING PARTICULARLY, it is often necessary to create patterns, either to match an existing piece or to fit a particular space. Also, in many instances, the form or design is traditional, so a relatively exact copy is required. The usual need is to enlarge the design.

There are a number of ways of achieving this. If it is a geometric design—arch, window shape, screen, panel—it can, of course, be laid out to size. It is usually easier, however, to work from a photograph or drawing. If the photo has been taken from almost directly in front of the middle of the subject, it will not be seriously distorted, so it can be blown up to whatever size is required, or can be photostated to size. If the negative is available, it is also possible to project the negative in an enlarger and sketch the design on paper or directly on the blank. This can also be done with a 35-mm or other size transparency; it can be projected onto a piece of paper over the screen and traced to a desired size. With transparencies, it is also possible to combine elements from several designs by projecting them in turn on the paper in proper size. This makes it possible to produce a pattern for a group of saints, a Nativity, or a screen pattern, by combining suitable individual figures.

An old-fashioned device for enlarging sketches, the pantograph, has recently become commercially available as well. It is a double-X device that can be set to give the desired enlargement. It is not particularly flexible, but will provide an outline for blanking a panel or similar work. The same thing can be done by using a long elastic band pinned at one side of the base print and with a pencil in the loop at the outer end. An ink mark is put on the band, at half its length for a 2X (doubled) image, at one-third its length for a 3X (tripled) image, and so on. A sheet of paper is placed in position beyond the base print, so the pencil can trace an outline while the ink mark follows the lines of the original (see Fig. 15—this is easier to do than describe). This method is not highly accurate, but will provide a silhouette for cutting and blanking.

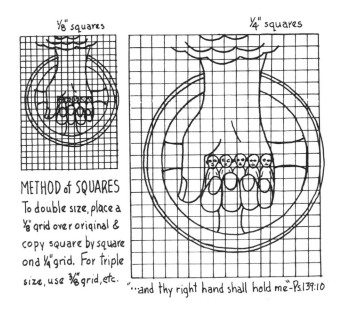

⅛″ squares ¼″ squares

METHOD of SQUARES

To double size, place a ⅛″ grid over original & copy square by square ond ¼″grid. For triple size, use ⅜″ grid, etc.

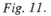

"...and thy right hand shall hold me"-Ps.139:10

Fig. 11.

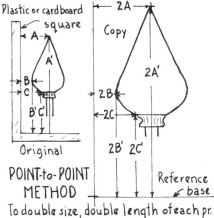

Plastic or cardboard square

2A

Copy

A

A'

2A'

B
C

2B

B'C'

2C

Original

2B' 2C'

POINT-to-POINT METHOD

Reference base

To double size, double length of each pr. of dimensions when transferred from original to copy, all measured from reference side & bottom lines. Connect located points & fair-in lines.

Fig. 12.

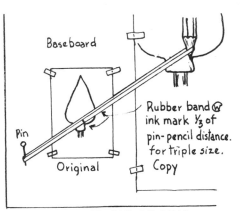

Baseboard

Pin

Rubber band ⓦ ink mark ⅓ of pin-pencil distance. for triple size.

Original Copy

RUBBER-BAND ENLARGING

Approximate locations & blank sizes can be obtained this way. Shown is **3X**.

Fig. 13.

19

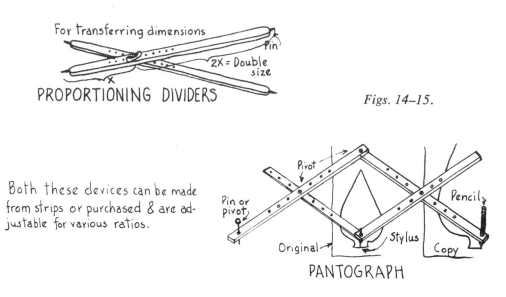

For transferring dimensions

Pin

2X = Double size

X

PROPORTIONING DIVIDERS

Figs. 14–15.

Both these devices can be made from strips or purchased & are adjustable for various ratios.

Pivot

Pin or pivot

Pencil

Original

Stylus

Copy

PANTOGRAPH

A basic method for enlarging is the method of squares. You begin by drawing a grid over the original, or better, drawing a grid on transparent paper or plastic so it can be re-used. A good basic scale is ⅛-in (3.2-mm) squares. If you want a sketch double-size, you draw a comparable grid on the copy paper of ¼-in (6.3-mm) squares. If the copy is to be triple size, you draw ⅜-in (9.6-mm) squares, and so on. Then you copy the original, square by square. This is slow, but quite accurate, the only problem is keeping track of just what square you are copying (see Fig. 11).

The method I use most commonly is the point-to-point (Fig. 12). To prepare for this, you draw a side and a base line on the original copy, or lay over it a square of plastic or cardboard, just outside the "live" portion of the design. Draw a similar side and base line on the copy paper. Now measure in from the side and up from the base line and transfer these measurements to the copy, in each case multiplying the measurement by the desired enlargement. For example, if you are doubling the size, and the measurements to a point on the original are 2½ in (6.3 cm) from the side and 4 in (10 cm) from the bottom, you lay out 5 and 8 in (12.7 and 20 cm) on the copy for that point. For triple size, you'd lay out 7½ and 12 in (19 and 30 cm). This is also slow, but extremely accurate. Once the key points are located, you simply draw the lines point-to-point. If you are in doubt about any location, you can add a pair of measurements and locate it. This method is particularly good for designs consisting of elaborate curves. The only problem is to select the

basic points by which to measure. By transposing original and copy, all the preceding methods except the elastic band can be used to reduce a design —in the pantograph you interchange pencil and stylus.

If you are starting with a 3-dimensional model and plan to increase or decrease the size, a pair of proportioning dividers will prove helpful. These are simply two sticks with pins on the ends, held together by a bolt with a thumbscrew. They work like double-ended calipers. If you're planning to double the size, you make the short arms half the length of the long ones. Then, any dimension you set on the short end will automatically be doubled on the other, and so on. The principle is the same as that for the pantograph.

CHAPTER IV

A Carved Dictionary of Christian Symbols

139 common religious symbols, framed by 104 forms of the cross

SYMBOLS OF RELIGION number in the thousands, and most of them are relatively flat designs, so they lend themselves to depiction in wood, metal, stained glass, and textiles, as well as more modern materials. A great many are relatively simple to carve; in fact, some can be shown with incised lines alone. They provide an excellent starting place for the novice carver of church decoration, and some kind of "dictionary" of the popular designs has long been needed. Hence, this panel is a visual compendium rather than a decoration and is intended to provide models.

A combination of factors dictated its shape and arrangement. I had a piece of English sycamore (harewood), a very white wood. When it was cleaned up, it had a rounded-top shape, 12½ in (32 cm) wide at the widest and 37 in (94 cm) long by almost 1 in (25.4 mm) thick. It resembled a headstone or a church window in perspective; it narrowed at the bottom because it was actually the full width of an inverted tree trunk. I had been asked at various times for church symbols and had made some pendants with religious motifs, all of which had excited my interest in liturgy.

There is little or no reason to duplicate this panel, unless you have a church school in mind, as I did. Further, individual units should be larger than I made them—at least twice the size—both to bring out the detail and to bring them within the functional range of conventional carving tools.

The original drawing was made with a normal relief panel in mind, but it soon became obvious that many designs were better executed by incising, or by combining incising with modelled relief. Also, I'd originally planned an uninterrupted frame of crosses, but found it more interesting and practical to make some complex crosses larger and project them above the bottom border, into an area in which the background was *not* bosted (or grounded out) in the conventional way. Also, the positions of some designs had to be changed for clearance and balance, while retaining some semblance of order. Compare the original drawing (Fig. 16) with the pictures (Figs. 17–21) and you'll see what I mean.

The pattern, as drawn, included a great deal of detail, much of it important, particularly as the size is increased. Some of it is difficult to execute in the size I chose, at least with the usual tools, unless one combines whittling and woodcarving, supplementing the smallest woodcarving tools with the pointed tip of a trusty pocketknife blade. After the pattern was drawn, I decided *not* to remove the central background, thus saving a great deal of time and effort. To obtain this result, it was necessary to trench around each element, a technique that is scarcely original (the Egyptians used it long ago). It means simply to trench around a design element so that it can be carved in relief, leaving the background high. (As I recall, the Egyptians actually incised their cuneiform letters into the background as well.) Thus the top unit, *1* and *2* (numbered in Fig. 16, pp. 26–29), is done in conventional relief, but units *8* and *13* are incised rather than relieved. It is only a step from this to units like the burning bush, *34*, in which relief carving and incising are combined to avoid a very difficult relief problem.

I tried to keep the symbols in a logical sequence and in orderly rows, without making it too apparent. Thus, on occasion, I have repositioned or enlarged a unit from drawing to carving; this is essential in carving panels, whether the reason be balance, space, or a flaw in the wood—it saves headaches not to be slavish. It is also advisable to reduce detail with size and wood—which I did not do in this instance.

I began with perhaps a dozen tools, but the number steadily decreased as the work went on. For trenching and outlining, I used a ¹⁄₁₆-in (1.6-mm) veiner, except where it was too large. If the design had a sharp edge, a ⅛- or ¼-in (3.2- or 6.3-mm) firmer set the line—or for precise curves, a suitable gouge. Background was removed with ⅛- and ¼-in (3.2 and 6.3-mm) flat gouges. These tools were not used free-hand; long ago I found that I have much greater control of the cut when I use a small mallet with an almost continuous light tapping. (The only problem with this technique in sycamore is that a long chip will form a curl that obscures the view, so cutting must be halted regularly to get the chip out of the way.)

Details were then carved with the tip of a pocketknife blade, and holes for eyes and the like were bored with it as well. Relatively early in the carving, I received the tiny firmers made by a friend in Portland, Oregon, from the stitching awls used on heavy-duty shoe machines. These had awl or burin handles and bent shanks, and were about ¹⁄₁₆ in and ⅛ in (1.6 and 3.2 mm) wide, and proved to be the best tools for grounding out, general smoothing and the like. From the same source, I also received a very small veiner that

had been ground into the butt of a ⅛-in (3.2-mm) twist drill with a ½-in (12.7-mm) dowel as handle. It proved to be the best tool available for cleaning up small flaws.

Designs are outlined with the veiner, as mentioned previously, but then the edge away from the figure is faired into the surface, so that the cut becomes one with a vertical wall outlining the figure and a sloping wall on the out or off side. In some cases, such cuts can be made with a V-tool laid on its side, but this technique tends to result in tears, particularly when the grain varies slightly. The sycamore is dense and straight-grained, but does have occasional areas where it is easier to cut in one direction than in the other, as well as an an occasional slight waviness, so that the tool tends to dig in one direction and not the other. In general, however, it is an excellent wood for work like this. An equivalent American wood would be holly.

In the effort to preserve the color of the wood, I resorted to a special finishing technique, with only middling results. Carving was intentionally not modelled to any degree, so there was a high percentage of surface area in the carvings as well as around them. After carving, these were sanded lightly with old and fine paper to remove burrs. The face of the panel was sprayed with matte varnish. Then Beiz 1411 (a light tan German sal-ammoniac stain) was carefully painted into depressions and wiped away from flat faces. Despite the wiping, the stain may obscure some detail, so it must be scraped away after it dries. The coat of varnish makes this possible, and also prevents the stain from over-darkening across-grain and end-grain areas. There is some tendency, however, for the varnish to yellow the wood, partly from its own make-up and perhaps partly from the wiped-over stain, so I felt it advisable to handscrape (with a spearblade knife) the entire surface, resand it lightly (again with very old and worn paper), and finish with two coats of hand-rubbed wax. This preserves the color contrast, and gives a soft and cleanable gloss to the panel.

Identification of the symbols

THE PANEL IS FRAMED by 104 forms of the cross, including Greek and Latin versions. Within it are 139 other symbols, some inevitably incorporating crosses as well and covering most of the range currently in use. It should be pointed out that a rigid distinction is made between symbols and types in church circles—"types" being subjects that include recognizable human beings, while symbols do not, although they may include animals, birds, fish,

and inanimate objects. Also, most symbols, when used in church decoration, are incorporated in circles or emblazoned on shields, or otherwise bordered. This is omitted here, whenever possible, to avoid uninteresting repetition in a concentrated panel. (This would not be true in a church, because the usual plan involves only a limited number of symbols in any one medium or area.)

These symbols may be reproduced in many ways, of course, including stained glass, embroidery, painting, gesso or plaster, formed metal, and wood-carving, and can range from simple outlines to fully modelled treatments if carved in wood. They may be painted or textured in some instances, and portrayed singly or in groups, as, for example, the symbols of the twelve Apostles surrounding the symbol of Christ. In fact, at the top of the panel is such a combination, taken from the Catacombs in Rome. It pictures the Greek alpha and omega (2), for "the beginning and the end" (Rev. I: 8) with the "Chi-Rho" emblem, a monogram for Christ using the first two letters of His name in ancient Greek uncials. (There are many such abbreviations now used as symbols, like the more popular IHS, which is wrong. It should be IHC, because it is from the Greek for Jesus. It does *not* stand for *Iesus Hominum Salvator*, "Jesus, Saviour of Mankind," even though some dictionaries say as much.) Note that the omega is not like the letter used today, but an older form. The doves of peace (*1*) are flanking decoration. Before we leave abbreviations, we should add that INRI stands for *Iesus Nazarenus Rex Iudaecorum*, "Jesus of Nazareth, King of the Jews," which was placed on the panel over His head on the cross, and that $\theta\Sigma$ (theta sigma) is an abbreviation for God. (The early form of the Greek sigma was like our capital C.)

Here are notes and identification of other symbols on the panel, roughly row by row and left to right:

Holy Trinity (Father, Son, Holy Ghost): The word "trinity" apparently was not used until the 3rd century, so early symbols for it are rare. It naturally suggested the equilateral triangle and three interlocking circles, or the triangle (or two triangles) interlocked with the circle of eternity, so there are endless variations of them extant. The symbols at left (*3*) combines three circles with an orb with a nimbus ("halo" is the wrong word) at its top. At far right (*7*) is the triquetra and circle interwoven. Flanking the large central *Hand of God* (*17*), two lines below, are two additional design forms, one combining triangle and trefoil (*16*), the other showing three fishes (*18*—the fish is a frequently used symbol for Christ).

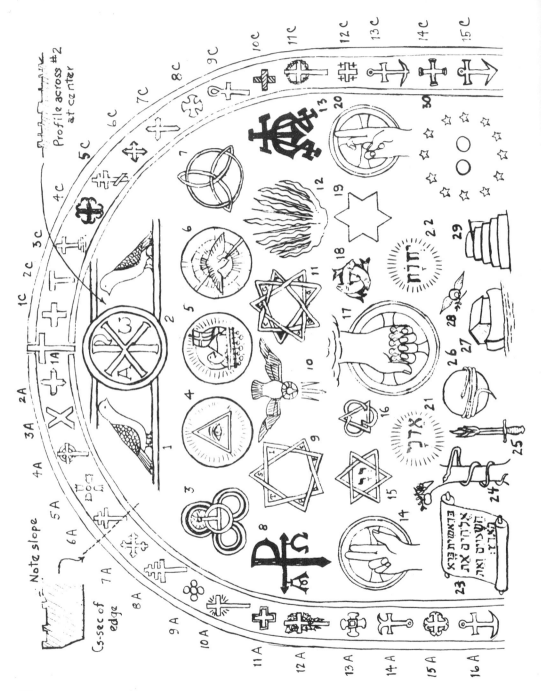

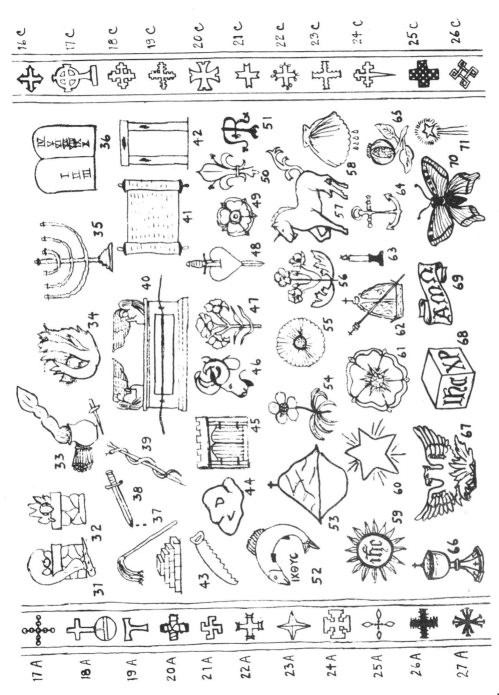

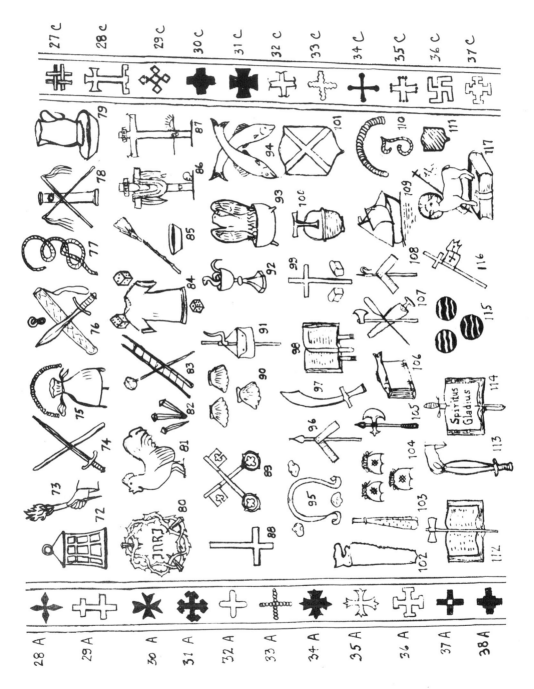

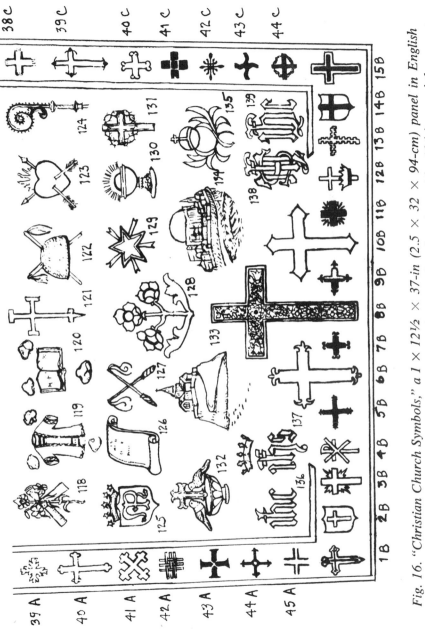

Fig. 16. "Christian Church Symbols," a 1 × 12½ × 37-in (2.5 × 32 × 94-cm) panel in English sycamore, has 139 symbols commonly used in Christian churches, framed by 104 forms of the cross. See the text and Figs. 17–21.

Father, Son and Holy Ghost: The three central disks show the Eye of God (*4*), the Agnus Dei on a book with seven seals for the Son (*5*), and the descending dove representing the Holy Ghost (*6*). These are perhaps the most common of the older symbols for the Trinity, expressed individually. Note that all are rayed or aureoled.

Alpha and Omega: At the ends of the second line of symbols are two additional depictions of the Alpha/Omega symbol: that at the left (*8*) from the Catacombs and including the "Chi-Rho" expressed as a cross; that at the right (*13*) combines the cross with the letters.

Holy Ghost: The four central figures are symbols for the Holy Ghost, none as familiar as the descending dove. First is the mystic seven-sided star (*9*), containing in the points the initial letters of the seven gifts of the Spirit: Sapientia, Intellectus, Consilium, Fortitudo, Scientia, Pietas and Timor (Old Testament, Is. 11); or the New Testament list (Rev. V: 12): Virtus, Divinitas, Sapientia, Fortitudo, Honor, Gloria, Benedicio. Next is the dove with nimbus (*10*). At far right (*12*) is the Seven-fold Flame, again expressing the seven gifts. (This is also shown as a seven-branched candlestick, seven flames, seven doves, etc.) Between the two is the nine-pointed star (*11*), representing the nine Fruits of the Spirit (Gal. V: 22), and incorporating the initial letters of the words: Caritas, Gaudium, Pax, Longanimitas, Benignitas, Bonitas, Fides, Mansuetudo, Continentia.

God, the Father: There are many symbols for God, but those in the third row show the major types. At far left is the Latin form of the Hand of God (*14*), with three fingers extended to show the Trinity, and two closed fingers to show the dual nature of the Son. At far right is the Greek form (*20*), with the fingers placed to form the four letters for the ancient Greek symbol for Jesus Christ. The central Hand (*17*) extends from a cloud and encloses the souls of the righteous—five human figures (Ps. 139: 10). Note that each is surrounded by a nimbus with three rays, repeating the Trinity. The six-pointed star (*19*) is called the Creator's Star, and is used in many shapes, as for example the double triangle (*15*) containing two Hebrew "yods"—the letter used in Hebrew to represent Jehovah and which was considered too sacred to be mentioned. (The double triangle is also considered as David's "shield.") Below, to the left of the central Hand, are the Hebrew words "The Lord" (*21*), and at right "Jehovah" (*22*), each surrounded by a rayed nimbus.

Old Testament: Rows 4, 5 and 6 show major events of the Old Testament.

The first is a scroll (23) showing the first verse of the Bible in Hebrew. Next is the Temptation and Fall (24), the Expulsion (25), Spread of Sin (26), two symbols for the Flood (the Ark—27—and the dove—28—with an olive branch), the Tower of Babel (29), all self-explanatory. The twelve stars surrounding the sun and full moon (30) represent Jacob and his wife and their twelve sons. In Row 5, the first two symbols are for Cain (31) and Abel (32); note that the flame and smoke of Cain's altar curl down to touch the bludgeon with which he slew his brother. Next is a combined symbol for Abraham and Isaac (33), Abraham being represented by the sacrificial knife, while Isaac by the bundle of sticks (sometimes shown as a crossed bundle) with the burning brazier indicating the sacrifice. Next is the burning bush, for Moses (34), and the seven-branched candlestick (35), which represents worship, as does the Ark of the Covenant (40) diagonally below it. Last on this line are the tablets of the Commandments (36), in this case arranged in the Catholic and Lutheran version. The Greek and Calvinistic sects have the numbers I through IV on the left side, and V through X on the right. In those cases in which the numbers are evenly divided (as in some Protestant churches), the first five commandments are said to represent piety, the second five probity. Some Christian churches avoid the problem by showing the commandments in Hebrew, which becomes a difficult carving operation.

Row 6 is relatively straightforward. The pile of bricks and taskmaster's whip (37) symbolize Israel in bondage; the dripping sword (38), the slaughter of the first-born (first of the ten plagues); the serpent and staff (39) represent one of the miracles Moses and Aaron performed before Pharaoh. Beyond the Ark of the Covenant (40) is a scroll (41) representing the Pentateuch, and a doorway with blood-smeared patch on the lintel and others on the posts (42) to suggest the Passover.

The Prophets and the Virgin Mary: Row 7 begins with the saw (43), the emblem of Isaiah's martyrdom. Next is the stone (44), emblem of Jeremiah's martyrdom, and a closed and turreted gate (45), the emblem of Ezekiel. Daniel is usually represented by a group of lions, by a four-horned ram (46—shown), or by a small figure of St. Mark on his shoulder—which becomes a "type" rather than a symbol. There are similar symbols for the twelve minor prophets, but no room for them here. There were also the sibyls and the twelve tribes of Israel, each of which had several symbols. The remaining symbols in this line are for the Virgin Mary, but that is in the New Testament.

New Testament: The Virgin Mary was anathema to the more extreme

Calvinists and Puritans, so many churches show no evidence of her at all. Among the favorite symbols for her during the Middle Ages were the Madonna lily (47), the heart pierced by a sword (48), the mystic or heraldic rose (49), the fleur-de-lys (50—probably a conventionalized form of the Annunciation or Madonna lily, later adopted by the French) and her monogram, which is especially interesting because the letters of both her Latin name, Maria, and her Hebrew name, Miriam, can be worked out of it (51), or the initials *A M R*, which in medieval days were said to represent *Ave Maria Regina*, or "Hail, Mary, the Queen."

Jesus Christ: There are dozens of symbols for Jesus, many dating back to the catacombs in various cities in which the bones of six million people were entombed betwen 72 and 410 AD. Shown in lines 8, 9 and 10 are twenty symbols for Jesus, while in lines 11 and 12 are fifteen symbols drawn specifically from the Passion. Most common in ancient times were the depictions of Jesus as a peasant lad with a lamb slung over his shoulders (a "type"), and the *Agnus Dei*, a lamb with three-armed nimbus resting on a book with seven seals and/or carrying the banner of victory (see 5). Almost as common was the fish (52, line 8), often with the rebus meaning "fish," but incorporating actually the initial letters of the Latin title, "Jesus Christ, Son of God, Saviour." It dates back to the first century. Next is the symbol of the Rock (53—I Cor. X: 4; Ps. XVIII: 2; etc.). The Christmas rose (54) also is used for The Nativity, and the daisy (55) expresses the innocence of the Holy Child. The Glastonbury thorn (56) is of later origin and comes from a legendary thorn tree in England that bloomed on Christmas Day. The unicorn (57—note goat beard, antelope back legs, lion's tail) denoted the Incarnation (the lion, ox, pelican and even serpent were also used). The scallop shell (58) is the symbol of the Baptism.

At the left (59) of line 9 is the Sun (of Righteousness), the Star (60— which also represents Epiphany and with three lengthened bottom rays—71 —the star of Jacob), and the Rose (61—Messianic promise). Other flowers used as symbols for Jesus include the rosemary, fleur-de-lys, gladiolus, and lilium candidum, as well as fruits such as the apple, olive and bursting pomegranate (65—far right), which symbolizes the Resurrection. The crown and scepter (62) express Christ's kingly office as well as Eternal Life; the candle (63) expresses "the Light of the World;" the anchor-cross (64) is the "anchor of the soul" (Heb. VI: 19—one of the oldest catacomb symbols).

In line 10, the ciborium (66) is also the symbol for the Last Supper, and the phoenix (67) represents the Resurrection (very widely used). Next is

the cornerstone (68—Eph. II: 20); the alpha/mu/omega scroll (69), meaning "yesterday, today and forever" (Heb. XIII: 8), and the butterfly (70), symbol also of eternal life. Other symbols include the peacock, dolphin, bee, egg, otter, stag, panther, remora, eagle, mermaid, centaur and swallow!

The Passion: This final period in the life of Jesus can be shown almost entirely in symbols (note those identified above). In line 11, the Roman lanthorn or lantern (72) symbolizes the betrayal (John XVIII: 3), as do the torch (73), the crossed sword and staff (74), and the purse with the arc of 30 coins above it (75). A sword and severed ear (76) symbolize the attack of Simon Peter on Malchus; the rope (77) stands for the binding of Christ's hands. The pillar with a ring near the top and/or two scourges crossed (78) symbolize the scourging by Pontius Pilate, who later "washed his hands" with the basin and ewer (79). In line 12 is the crown of thorns (80), the crowing cock (81—Simon Peter's denial), and the three nails with which Jesus was impaled (82). The universal symbol for the Crucifixion is the Cross (86 and 87—but without robe or nails, and usually with Jesus upon it), just as the universal symbol of the Agony in Gethsemane is a cross rising from a chalice. These are the only two of the so-called "thirteen symbols of the Passion" that are standard.

Next is the ladder and sponge (83), and the seamless coat (84) surrounded by the dice the soldiers cast for it, the reed and hyssop (85), and then two forms of the empty cross, one with winding sheet draped over it and Adam's skull at its base (86), the other with the nails reinserted and the rising sun (87). In each case, the top plaque bears the letters INRI, of course. Among other symbols used for the Passion are the pincers supposedly used to draw out the nails, the hammer with which they were driven, the tomb of Joseph with the circular door-stone, a heart pierced by a lance, a passion flower, even the hands, heart and feet pierced with wounds.

The Twelve Apostles: Each of the original twelve disciples has several symbols; two are shown here for each (lines 13 to 15). They are usually placed in shields, like coats of arms. The inverted cross (88) and the crossed keys (89) symbolize St. Peter—he died on the first; and the second is from Matt. XVI: 13–19. St. James the Greater was the pilgrim, symbolized by three scallop shells (90) or the pilgrim's staff and wallet (91). St. John as an Apostle (rather than as an Evangelist) is symbolized by a serpent rising from a chalice (92) or an eagle rising from a cauldron of boiling oil (93)— both poison and boiling oil were used in attempts to kill him. St. Andrew is symbolized by crossed fishes (94) or by the St. Andrew's cross (101) on

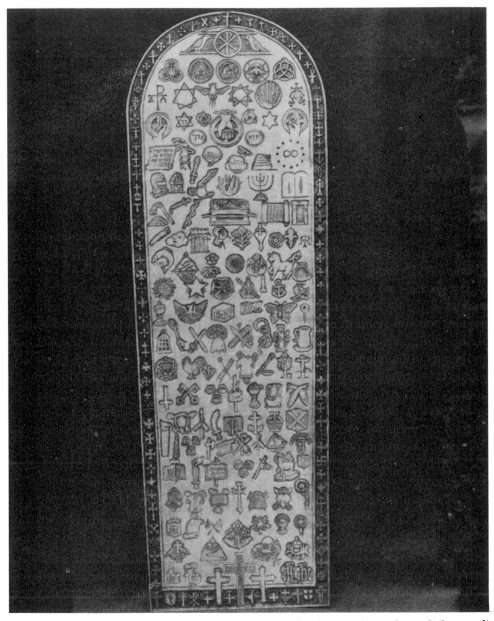

Fig. 17. "Christian Church Symbols" panel. The background was bosted (lowered) only in the border and within some symbols. The symbols themselves may be low-relief, trenched (outside background not lowered), or incised, or a combination. A slightly darker stain makes the design elements stand out.

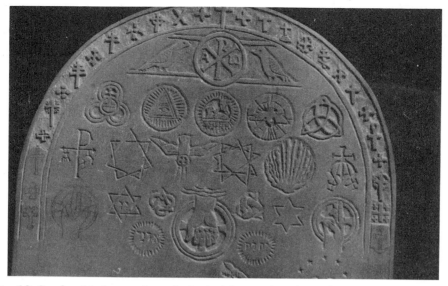

Fig. 18. In the third row of symbols, incising replaced relief on delicate lines. Outer symbols and stars are incised, the flame is low relief, and the dove is a combination of the two, with bird in low relief and rays incised.

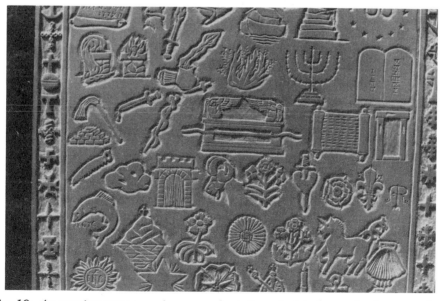

Fig. 19. As carving progressed, many adaptations had to be made. In general, relief was very shallow to leave plenty of flat surfaces. Spacing and size of units were varied for better visual appearance.

35

which he is said to have died in Greece. St. Thomas is the patron saint of builders, and is symbolized either by a leather girdle and stones (95—he was stoned and speared to death in India) or a carpenter's square with (96) or without a spear. St. Bartholomew (thought to be the same as Nathanael) was skinned alive, then crucified, so his symbols include the scimitar (97), and a Bible with a flaying knife on it (98), or three flaying knives side by side (not shown). St. Philip is remembered for his remark (John VI: 7) when Jesus fed the multitude, by the symbol of a cross with two loaves of bread (99), or by a Tau cross rising from a basket (100).

At the left end of line 15 are two symbols for St. James the Less: a vertical saw with handle on top (102) and a vertical fuller's bat (103), both having to do with his martyrdom. When St. Matthew is symbolized as an Apostle, it is usually as three purses (104)—he was originally a money changer—or a battleaxe (105). St. Simon is depicted by a fish lying upon a book (106—he was said to be a great fisher of men through the Gospel) or a big saw and oar crossed, with (107) or without a battleaxe. St. Jude, also called Thaddeus, travelled with Simon on missionary journeys, so his symbol is a boat with cross-shaped sail and mast (109), or a carpenter's square superimposed on a boat hook (108). Lastly, there is Judas Iscariot, who is frequently not depicted. Two possible symbols for him are a rope formed like the letter J surmounted by an arc of the 30 pieces of silver (110), or a dingy yellow blank shield (111). His replacement, St. Matthias, is usually depicted by an open Bible topped with a primitive battleaxe (112), less often by a sword or scimitar suspended by its point (113).

Others: Often shown with emblems of the other Apostles are those of St. Paul, of which the most familiar is an open Bible bearing the words *Spiritus Gladius* (114), with the cross-hilted sword of the Spirit behind it. The three heraldic fountains (115) are another version. St. John the Baptist is commonly depicted by the nimbused Lamb standing upon a book and bearing the Banner of Victory, sometimes with the words *Ecce Agnus Dei* (117). A simpler form is just the Banner of Victory (116). Line 17 shows symbols for other saints, beginning with the lily and carpenter's square for St. Joseph (118), the coat and stones for St. Stephen (119), and the Bible open to St. Matthew, with stones for St. Barnabas (120). St. Jerome, foremost of the Western (or Latin) Fathers (340-420 AD), who did much of the Vulgate translation of the Bible into Latin, has many symbols, of which a common one is the Cross Potent Filched (121). St. Ambrose (340–397 AD), the famous Bishop of Milan and father of church music, is symbolized by a bee-

hive (for eloquence) backed by knotted crossed scourges (*122*), because he once demanded that the emperor do penance for his sins. St. Augustine of Hippo (354–430 AD) wrote the famous *Confessions* and is most commonly symbolized by a heart topped by heraldic flame and pierced by two arrows (*123*), signifying his remorse for the follies of his youth. St. Gregory the Great (540–604 AD) was one of the early popes and originated the Gregorian Chants. His usual symbol is a bishop's crozier or staff (*124*).

The Church Year: There are symbols for each portion of the church year, of which some are shown in Lines 17 and 18. First is the Immaculate Conception, the monogram of the Virgin surmounted by a crown with five stars (*125*); next, a scroll (*126*) for Advent, crossed scourges for Lent (*127*), the Christmas rose for Christmas (*128*), the Epiphany star (*129*), the chalice with rising sun for Maundy Thursday (*130*), and the thorned cross for Good Friday (*131*). On the next line are the chalice with cross and doves for Purification (*132*), and the orb and cross with palms for Good Friday (*135* —far right). Between them are the symbols for the "house on a rock" in one of Christ's parables (*133*), and the "city set on a hill" (*134*).

The IHS Symbol: This is a frequently used monogram, which is correctly IHC (without periods), as discussed earlier, but which is now frequently depicted as IHS. Two forms of each are shown on the final line (*136, 137, 138, 139*).

Note: There are many additional symbols for vessels, vestments, saints, sacraments and the like, but I have tried to make a selection to fit my particular needs. Anyone undertaking a comprehensive project in symbolism is well advised to research it thoroughly to suit the particular denomination, because many clergymen have a limited—and sometimes incorrect—knowledge of the subject. This is the only way to explain some of the mistaken or poorly executed symbols in many modern churches, including crosses that are badly proportioned or have incorrect arms, incorrect phrases or monograms, even wrongly assigned symbols. It is essential that if symbolism is to be used, it should depict, and well, what it is supposed to depict—for the immediate congregation at least.

Forms of the cross (in frame)

THE CROSS IS A NATURAL SHAPE that has found a place in many religions; I remember seeing two high on a hill in a semi-pagan Indian town in southern Mexico, and being told that they represented doors to the afterworld. The

cross has been used—and abused—through the centuries, and deserves to be better understood.

The **Latin Cross** (*1A*—see pp. 26–29), top middle of the border, is known as the *Crux immissa*, and is most often improperly designed. It should be slender and graceful. A good rule is to regard it as twelve squares, eight forming the vertical and two on each side for the crossbar, which is aligned with the third vertical square from the top. It can be thinner, but not thicker, and should be made octagonal in cross-section when placed high up, to reduce its heaviness when seen from below. I have not included in this group the crucifix, which shows Jesus impaled, because it is not a symbol as much as it is a "type" in that it includes a human being; or the cross with symbols of the four evangelists at its ends, or *Agnus Dei* in the crossing, because these deserve to be mounted individually, rather than being included with other symbols. Others of the 104 crosses shown include both religious and heraldic ones (there is no clear dividing line); they include the most important of the more than 400 forms of the cross and all of the 50 or more commonly used in liturgical art. They are identified here in order, starting at the left:

Cross Aiguisée (*2A*): Heraldic derivation. Ends couped (cut square) and obtuse points added. Symbol of the Passion.

Saltire or St. Andrew's Cross (*3A*): Also the *Crux decussata*, Scottish cross, Irish, St. Albans. St. Andrew, the Apostle, died on such a cross. Arms are equal length, crossed like an "X." Symbol of the beginning and end of the Christian church year, martyrdom, humility.

Celtic Cross (*4A*): Also the Irish cross and a simple form of the Cross of Iona. Very ancient. The circle represents eternity, and is usually carved in a plane behind the cross, which may thicken towards the base and is hollowed slightly at all four corners of the crossing. Larger Celtic crosses are usually elaborately surface-carved with Celtic or vine patterns, medallions, etc. When Protestants in England banned the Latin cross, this one was used and called the "disguised cross."

Cross Avellaine (*5A*): Decorative and heraldic, resembling four husks of the *nux avellana*. Used atop St. Paul's in London.

Patriarchal Cross (*6A*): Upper arm represents the inscription placed over Jesus' head at crucifixion. Carried by certain patriarchs.

Cross Botonnée, Bourbonée, or Trefflée (*7A*): Often used on cornerstones and the covers of hymnals. Limbs terminate in trefoils. Very decorative.

Fig. 20. Balancing of design elements was crucial, so contiguous border crosses are of similar height and complexity. Also, the most detailed cross is centered at the bottom and enlarged to project through the border, as do two flanking crosses.

Papal Cross (*8A*): Carried before the Pope in processions and reserved for him.

Cross Bezant (*9A*): Five golden disks (or seven, if lengthened), or golden disks on the face of a standard cross.

Cross in Glory, Rayed Cross, Easter Cross (*10A*): Represents the sun behind a Latin cross. Usually only in white.

Bordered, Fimbriated or Edged Cross (*11*A): Much used in printing, heraldry, stained glass. Edge is outlined or bordered, usually in contrasting color.

Easter Cross (*12A*): Actually a form of cross in glory, with Easter lilies twined around it. Used only at Eastertide.

Canterbury Cross (*13A*): Four hammerlike arms spring from a square, which may be solid or bordered.

Anchored Cross (*14A*): From the catacombs, an inverted anchor combined with the cross. Symbol of hope.

Anchored Cross II (*15*): Heraldic in origin, cross ends terminating in anchor flukes.

Anchored Cross III (*16A*): Primarily an anchor with crossbar strengthened to show the cross.

Chain Cross (*17A*): Originated during heraldry; now used to symbolize the breaking of the fetters of sin. Five links on each arm.

Cross of Triumph, Victory, Conquest, Cross & Orb, Cross Triumphant (*18A*): Small Latin cross atop a banded globe. Commonly used on spires and sceptres and as a hand-held, in-the-round symbol.

Tau Cross (*19A*): Used at Advent, a true letter form. Compare with *Tau Cross*, second from top on right.

Cross Cordée or Corded Cross (*20A*): Heraldic origin, symbolizes cord used to bind Jesus.

Cross Cramponée (*21A*): Similar to the Swastika, but with shorter arms. A *Cross Potent*.

Cross Croissant or Crescented Cross (*22A*): From heraldry; limbs terminate in crescents.

Cross Etoile (*23A*): Four-pointed star form.

Cross Degraded (*24A*): Limbs end in steps which touch edges of shield upon which it is usually shown. Heraldic in origin.

Cross of Four Ermine Spots (*25A*): Decorative; four heraldic ermine spots.

Cross Flamant (*26A*): Flame-like edges, symbolizing religious zeal. Unusual.

Cross of Four Pheons (*27A*): Heraldic, showing four dart heads whose points touch. Inner edges of the dart heads are serrated. Symbol of "the fiery darts of the wicked."

Cross of the Four Fusils (*28A*): Four elongated lozenges, usually shown in solid color.

Cross of Lorraine (*29A*): Similar to the *Patriarchal Cross*, except that the longer bar is nearer the base. Symbol of the Holy League.

Maltese Cross (*30A*): Resembles four spearheads with points touching. Eight outer points must be equidistant. Also called *Regeneration Cross, Beatitudes Cross*. Symbol of St. John's Day and worn by Knights Hospitallers. Do not confuse with *Cross Patée* (*34A*).

Cross Millrine (*31A*): Ends said to resemble the clamp on an upper millstone.

Cross Moussue (*32A*): Semicircular ends on limbs.

Paternoster Cross (*33A*): Two crossing strings of discs, suggesting a string of beads. Symbolic of prayer.

Cross Patée (*34A*): Very decorative and widely used, both in Greek and Latin (extended base) forms. The limbs curve outward, and outer edges are straight. Variations are endless; the one sketched is *Cross Patée Fitched* because of the added points. If outer edges curve outward, it is a *Patée Convex*; if they curve inward, a *Patée Concave*; if scalloped, a *Patée Invected*. If designed within a circle, it is the *Cross Alisée Patée*. It is also combined with other forms, like the *Quadrate*, the *Patonce*, the *Fleurée*, the *Clechée*. If large, it should be done in outline only.

Cross Patonce (*35A*): Similar to *Cross Fleurée*, except that arms are more expanded.

Cross Potent (*36A*): Also called *Jerusalem Cross*. Four *Tau* crosses whose bases meet. Titled from resemblance of the arms to ancient crutches, hence symbolic of healing.

Cross Quarterly Pierced (*37A*): Square hole the full width of the arms where they cross. If the hole is circular, it is called *Cross Pierced*, if much smaller, *Quarter-pierced*.

Cross Quadrate (*38A*): A square covers the intersection of the arms.

Cross Ragulée (*39A*): A knotted cross; protrusions on the arm suggest the knots and lopped-off branches of a tree.

Cross Botonnée (Latin) (*40A*): See earlier note. If intersection is circled, it is called *Botonnée Nowy*.

St. Julian's Cross (*41A*): Also called *Cross Crosslet Saltire* in heraldry. Four Latin crosses with overlapping bases, used at Epiphany to suggest Christianity spreading to the four corners of the earth.

Triparted Cross (*42A*): Three vertical and three horizontal limbs of equal length, interwoven to suggest basketweaving; see *Triparted Fleurée*.

Cross Vair (*43A*): Named from the heraldic fur, vair; arms.

Center-voided Cross (*44A*): Any shape of cross, with central circlet.

Cross Voided (*45A*): Any shape of cross, shown in outline only, so background is visible.

Bottom Row, from left:

St. James Cross or **Spanish Cross, Cross of the Knights of St. Iago** (*1B*): Any cross with heart-shaped top and sword-tipped lower limb, with side arms terminating *fleurée* (three petals, like *Cross Fleurée*).

Shield of Faith (*2B*): Latin cross superimposed on a shield, but not touching the edges (as they do in St. George Cross at bottom right). Emblem of faith.

Cross Flamant II (*3B*): An alternate to *26A*, with triple flames from each corner of the intersection of limbs. More decorative.

Cross of Constantine (*4B*): Combination of the Latin cross and the *Chi-Rho* symbol, said to have been seen by Constantine together with the words *In hoc signo vinces*. Symbol for Ascension Day.

Cross Fleur-de-Lys (*5B*): Like the *Cross Fleurée*, except that couped ends of limbs are terminated by complete fleur-de-lys. Symbol of the Holy Trinity.

Latin Cross Fleurettée (*6B*): Again like the *Cross Fleurée*, but with half fleur-de-lys on the ends of limbs. Symbol of the Holy Trinity.

Cross Fer-de-Fourchette (*7B*): Heraldic origin. Ends resemble forked irons used to support early muskets during firing.

Cross Adorned (*8B*): *Latin Cross* with carved or painted floral forms, Easter lilies, Passion flowers, vines, etc. May have plain or beaded edge moldings, fleur-de-lys at limb ends, etc.

Cross Fleurettée-Moussue (*9B*): Rounded ends on limbs. This one is countercharged—the term for central division into two colors or textures.

Latin Cross Clechée (*10B*): Spear-like ends, usually with small knots or loops, often voided to show a smaller cross of similar shape inside.

Greek Cross Flamant (*11B*): A familiar form, said to suggest the sun rising behind the cross.

Cross and Kingly Crown (*12B*): Once common on bookmarks. Usually a *Cross Botonnée* thrust through the Crown of Eternal Life.

Cross Bretissée (*13B*): Like *Cross Embattled*, except that indentations resembling battlements are not opposite each other. Symbol of church miliant.

St. George's Cross (*14B*): Red on a white field; the cross of England.

Voided Latin Cross or Double Cross (*15B*): Inner cross may be of slightly different shape or color, or show background.

Right column, starting at top:

Greek Cross (*1C*): Made of seven squares each way in proper form, thus slender like the *Latin Cross*. Very ancient. Commonly used in Greek churches in a group of five, to suggest the five wounds of Jesus on the cross.

Tau Cross, Old Testament Cross, Anticipatory Cross, Cross Commissée,

Egyptian Cross, Advent Cross, St. Anthony's Cross (*2C*): Very ancient; said to be the form Moses raised in the desert and that upon which the two thieves were hung at the Crucifixion. Cross of prophecy, used at Advent.

Graded Cross (*3C*): *Latin Cross* with vertical member eight to ten squares high, and arms five to seven squares (total) long. It stands on three steps, representing faith, hope and charity, reading from the top down. Common on altars.

Cross Cercelée (*4C*): Like an anchored cross, except that ends resemble ram's horns.

Eastern Cross (*5C*): A slender *Latin Cross*, with nameplate added at top and sloping "footrest" at bottom. The slope of the footrest is less than 45° with horizontal, and overall length is the same as that of the usual cross-arm, except that outer ends are cut off vertical. Cross-arm must be dexter—sloping down to the right. Used on Eastern Orthodox churches. Angle of footrest is traditional, because Orthodox people believe Jesus' feet were not centered but

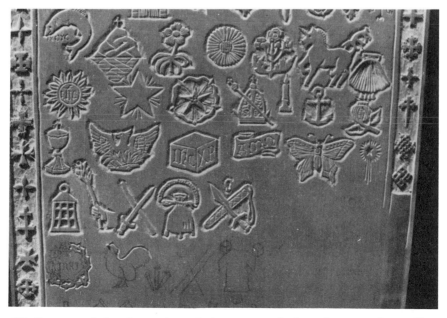

Fig. 21. In general, border and symbols were worked at the same time. Also note that some designs crowd others.

spread apart. Some suggest the footrest was displaced by the subsequent earthquake, etc., but probable real explanation is that it suggests the *Cross Saltire*, because St. Andrew introduced Christianity into Russia.

Cross Barbée (*6C*): Ends of limbs resemble barbed fish spears. Symbol like ICHTHUS for Jesus, also for "fishers of men."

Passion Cross, Cross Urdée, Cross Champain (*7C*): Limb ends cut to points to represent Jesus' suffering. If rising from a chalice, it represents His agony in Gethsemane, and can be a symbol of Maundy Thursday or Good Friday. Also called *Cross of Suffering*.

Cross Alisée Patée (*8C*): The *Cross Patée* (see *34A*) designed to go within a circle.

Crux Ansata, or Ankh (*9C*): Ancient Egyptian origin, and symbol of life. It is either a *Tau Cross* or a *Latin Cross*, with a loop above it.

Cross Cablée (*10C*): The members resemble cables or ropes. Purely decorative.

Cross and Thorny Crown (*11C*): Very slender *Latin Cross* with a crown of thorns twined about it. A Passion symbol, it represents Good Friday.

Cross Cantonée (*12C*): Any large cross closely surrounded by four smaller ones of similar design.

Anchored Cross IV (*13C*): Flukes precise, a symbol of hope.

Cross Capital, Cross Chapiteau (*14C*): From heraldry; limbs terminate in capitals, suggesting columns. A variation is the *Cross Cotised*, with limb ends carrying scrolls, said to represent the Four Gospels.

Anchored Cross V (*15C*): Stylized, to emphasize the cross. Ancient form.

Greek Cross Clechée (*16C*): Spearlike ends with heavy borders to create a smaller cross of similar design but contrasting color or texture inside.

Cross of Iona (*17C*): Design with flared ends and set on a base. The *Irish Cross*.

Cross Crosslet (*18C*): Four *Latin Crosses* with overlapping bases. Represents Epiphany. See *St. Julian's Cross* (*41A*).

Cross Crenellée (*19C*): Limbs have *matched* indentations, in contrast to *Cross Bretissée*, similar to battlements, so is also called the *Embattled Cross*. Symbol of the church militant.

Cross Demi-Sarcelled (*20C*): Of the *Patée* type, but with square indentations on outer edges.

Cross Double-Fitchée (*21C*): Limb ends terminate in double points.

Cross Entailed (*22C*): From heraldry and like the *Cross Clechée*, except that ends of limbs are ornamented with three loops. Largely decorative and usually voided.

Cross Engrailed (*23C*): Thorny projections on arms, so edges are formed of concave loops. If edges are notched instead, like a saw, it becomes a *Cross Indented*, and if indentations are very fine, a *Cross Dancette*. If notches are dovetail shape, it becomes a *Cross Dovetailed*.

Cross Fitchée (*24C*): Lower arm drawn to a point. Said to have originated during the Crusades, so the Cross could be thrust into the ground for daily devotions. This is a *Cross Crosslet*, but any form of cross can be fitched.

Cross Chequy, Cross Echiquette (*25C*): Composed of at least three rows of alternating color or texture in squares, like a checkerboard.

Cross Frettée (*26C*): Heraldic and decorative; the interlaced band composing five perfect squares. Differs from the *Cross Mascly* (*29C*), in which voided squares barely touch.

Cross Interlaced (*27C*): Four members woven together like reeds.

Cross Lambeau (*28C*): A *Cross Patée* with a long lower limb resting upon a bar with three pendant labels. The bar, in heraldry, also meant eldest son.

Cross Mascly (*29C*): Five voided squares touching at points.

Cross Nowy (*30C*): Sphere or disk covering limb crossing makes any cross *Nowy*.

Cross Patée (*31C*): Limbs curve outward and ends are straight. The base of many variations that are quite decorative.

Cross Moline (*32C*): Each arm ends in two petals.

Cross Nebulée (*33C*): Somewhat like a dovetailed cross, except that ends of notches are rounded rather than pointed.

Cross Pommée (*34C*): Arms end in single knobs.

Cross Pommettée (*35C*): Like the preceding, except that arms end in double or triple knobs.

Cross Rebated, Fylfot, Swastika (*36C*): Prehistoric form in many lands. May have represented the four points of the compass to some, but usually had religious significance.

St. Chad's Cross, Cross Potent Quadrate (*37C*): Four *Tau Crosses* with their bases meeting under a central square.

Sixteen-pointed Cross (*38C*): Each limb ends in four points, like fringe or the teeth of a saw.

Latin Cross Fleurée (*39C*): Limbs terminate in three petals.

Cross Pommettée II (*40C*): Double knobs terminate limbs.

Cross Trononée, Dismembered Cross (*41C*): Any cross cut into five or more parts, so the field shows between them.

Triparted Fleurée Cross (*42C*): Six members crossing, with members terminating in petal shapes to suggest the fleur-de-lys.

Cross Wavy (*43C*): Heraldic, with undulating arms like conventionalized waves.

Cross Wreathed (*44C*): Interlaced circlet of thorns or leaves. Thorns for suffering, laurel for victory, cypress for immortality, oak for strength, bay for death.

Fig. 22. Tools for the work were quite simple: a pocketknife, two replaceable-blade knives (one with a concave edge), and two burin-type bent chisels. The tools were small because the work was small and the wood was hard and dense.

CHAPTER V

The Symbols of Christmas

BECAUSE IT INCORPORATES MANY PAGAN CUSTOMS and practices, there are more symbols connected with Christmas than with any other Christian holiday. This fact has long intrigued me, but not until recently did it translate into an idea for a panel.

My original intention was to carve a panel for a Christmas card decoration. I had available a 100-year-old mahogany table leaf with a beautiful patina (which seemed a shame to damage), as well as an obviously hand-made shape. Actually, relief carving can be quite shallow if the subject warrants it; witness scrimshaw, the cave carvings of primitives, and the carving of chair seats and tabletops. On occasion, it may be enough to use only lines or minimum shaping, or modelling that leaves much of the surface flat and undisturbed. This will also affect the patina less, and will be strong and quite visible if sharp contrast is retained in finishing. In this case, the usual order is reversed—the figures are left dark, the background light.

It is not always advisable to work over an entire surface and model every unit of a design, or to blend all surfaces and contours. Even a carving which is· to hang vertically will, in the course of time, collect dust and grease from the atmosphere which will be difficult to remove without damaging the carving itself; and the deeper the relief, the greater the number of fragile elements. In Europe, much of the medieval carving in choir stalls and retablos is so dust-covered as to be unsightly; it is simply not practicable to keep the dust out of a church. (This may well have been one reason for painting carvings; another, of course, was the lack of lighting.)

My determination was to preserve at least some of the patina of my 12 × 36-in (30 × 91-cm) table leaf, so I decided on shallow relief, minimum modelling, and "bleeding" of the designs into the upper borders. I carved largely in lines, even on detailed subjects—the three-dimensional equivalent of pencil sketching. I also limited modelling to a minimum, so the figures themselves have largely flat surfaces that retain the patina. This also reversed the usual panel contrast in that the surface is dark and the background light.

The outer edges, which had a bevel (except for the mating edge, which became the bottom of my panel), were left undisturbed to serve as a frame. By making the background depth quite shallow, I could "bleed" complex figures off the edge, thus suggesting them without carving the entire subject. An example is the Christmas tree, in which a couple of branches suggest the entire tree. This also makes it possible for the beveled border to hold the entire composition together and makes a separate frame unnecessary. (In panel carving, many carvers feel that a frame is required because paintings have them, and then weaken the carving substantially by adding one.)

This entire panel is a formidable task, but individual elements may be selected or combined into a smaller composition. It reduces modelling to its essentials, so is a good exercise. In the absence of a board with a similar patina, you can create the same effect by painting or staining the surface in a contrasting color, then carving through the surface to the wood beneath. This trick is commonly used in Fiji, Australia and the USSR in decorating utilitarian shapes or in adding the purchaser's name to the carving on a tourist item. This loses the surface texture of the wood, but permits a cheaper and softer wood to be used for a plate, bowl, candlestick, plaque or chalice.

Many techniques can be used in a carving like this. There can be variations in line width or shape (various vees or rounded gouge cuts), cross-hatching, lining, trenching around a carving or trenching within it. This latter technique was also used by the Egyptians, who outlined the subject, then cut away the surface of the subject to model it, thereby leaving the background high. Any of these cuts breaks up impinging light, giving the cut a darker tone that can be enhanced by "antiquing." (This is simply adding a darker stain in desired areas.)

In a design like this, I often start at one corner, adding suitable elements just ahead of my carving them. It is necessary, in such an approach, to plan ahead at least enough to retain balance (to balance a fireplace in one corner with a fireplace or similar blocky element in the opposite corner, for example) and to make certain that the spacing and size of units is relatively equal. If this is done, elements can be inserted where they fit, with their exact shape altered or cut off to suit. Also, this makes it possible to finish and admire each unit as you carve it. It is much like finishing as many small panels as there are elements in the design—something that cannot be done with in-the-round carving, in which a great deal of wood must be cut away before the design begins to emerge.

In this particular panel, it seemed advisable to do the most complex

element first, then to group the others around it. Thus I began at the middle, with the Nativity scene and the star above it, then carved the corner fireplaces. One word of caution: if you plan to do such a panel on any subject, you'd better have a general idea of how many elements are available; I have on occasion had to do additional research to fill odd spots to complete the work!

If you follow the conventional approach and make the layout on paper first, such problems are avoided, but so is some of the excitement. (The same can be said for modelling a 3D figure in clay as a preliminary to carving. It's safer and surer, but much less precarious and requires much less ingenuity. It also presents problems—at least for me—in total time spent as well as in trying to duplicate the clay model in wood.)

The symbols of Christmas

WHEN WILLIAM MAW EGLEY, JR. DREW the first Christmas card in England on December 9, 1842, he certainly had no idea how hackneyed and commercialized his idea would become, particularly in the United States. But this 16-year-old perhaps rendered a greater service by initiating a visual device for keeping the many symbols of Christmas alive.

Many Christmas customs depicted actually predate the holiday itself, which was not one of the earliest Christian festivals; they had to do rather with the winter solstice, well known to so-called pagans. The selections shown in the panel on pages 50–51 are in random order to fit the rather unusual shape of the panel.

You will find the symbols on the following pages, starting at lower left and progressing up, then down, across the panel (I have provided explanations where the symbol may be obscure).

Fig. 23. "The Symbols of Christmas." These 37 designs may be used individually or grouped to fit a particular space.

1. Yule log (England)
2. Holly (on mantel)
3. Bells
4. Poinsettia
5. Archangel with halo
6. Candles (Germany)
7. Christmas elf (Eastern Europe)
8. Santa Claus and chimney
9. Plum pudding (England)
10. Mistletoe branch
11. Boar's head (England)
12. Wassail bowl (England)
13. Mulled ale (England)
14. Lute and recorders
15. Gifts
16. Cherub with trumpet
17. Carolers (England)
18. Piñata (Mexico)
19. Urn of Fate (Italy—left at Epiphany with food for the Magi, who replace it with gifts)
20. Star of Bethlehem
21. Nativity scene with shepherds and animals (Italy)

22. Christmas seal (Denmark)
23. Christmas cookies and candy
24. Choir
25. Tiny Tim with Bob Cratchit
26. Lucia Krona (Sweden—St. Lucy's crown, worn December 13 to start the observances)
27. Wooden shoes with straw (Holland—put out for Kris Kringle's white horse, and replaced with gifts. A similar custom in Italy involves food for the witch, La Befana, who replaces food with gifts at Epiphany—or with ashes for a naughty child)

28. Little drummer boy (modern)
29. Rudolph, the rednosed reindeer (also quite modern)
30. Lord of Misrule (England)
31. Miracle Plays (England—represented here by mummer's masks of the dragon, St. George, and the judge)
32. Magi, or Three Wise Men
33. Ivy (England—on mantel)
34. Stockings (on mantel)
35. Christmas tree (Germany)
36. Santa's sleigh (Germany)
37. Santa's Elf (Germany)

CHAPTER VI

Make Religious Pendants

PENDANTS, TO BE WORN ON A CHAIN, hung from a Christmas tree, or even hung individually as unit mobiles, have become very much in vogue in recent years. The most familiar form is the cross, which can be made in infinite variety (see Figs. 24–28). Shown here are some variations, aimed at intriguing people who already have cross pendants in wood or other materials.

First is a series of pendants utilizing the cross as the major decoration, but relying upon shape and wood for variety. They can be made from scraps of exotic woods, with the front surface sanded smooth and the cross incised with a veiner or V-tool. The cross shape is tinted with gilt or silver, depending upon the color of the wood, and the pendant completed by inserting a small gilt or silver screw-eye of the type jewelers use. (Threads on these eyes are so fine that it is advisable to glue them in rather than relying upon the threads to hold.)

There are many other subjects, depending upon season and local preference. They include Santa Claus, angels, carolers, even the moon, a simple grained oval or circle (highly polished), and gnomes. They can be made as relief-carved silhouettes or as in-the-round figures, the latter commanding, and justifying, a considerably higher sales price.

The cross itself, whether cut as a single piece or made by crossing pieces, is basically not so much a carving as a cabinetmaking job; however, the surface can be decorated by carving. I have pictured and sketched one of the more effective crosses of this type (Fig. 26), sawed as a unit from olive wood, sanded, and textured by almost random fluter cuts. Other possibilities include thin crosses with elaborate outlines ranging from a fire or wave pattern to fretwork, and hardwood (ebony, vermilion, teak, walnut) crosses with a smaller cross of silver wire inlaid. Figures such as the carolers, snowman and angels can be whittled of soft wood and painted, of course.

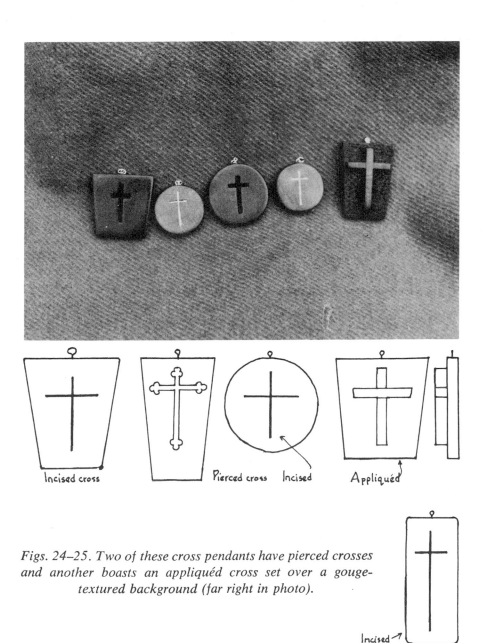

Figs. 24–25. Two of these cross pendants have pierced crosses and another boasts an appliquéd cross set over a gouge-textured background (far right in photo).

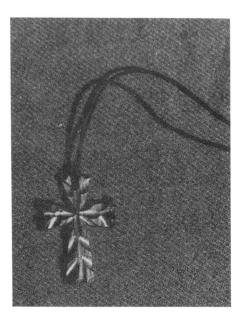

CROSS PENDANT

Fig. 26. This olive-wood cross from Spain has a smaller cross cut into the center and the edges are gouge-cut, all with the same fluter. It is suspended from a thong passed through a drilled hole, and is about 1½ in (4 cm) long.

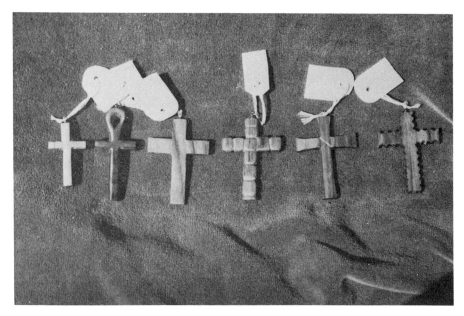

Fig. 27. These crosses are made of teak and are about 2 in (5 cm) long. The second from the left is actually an "ankh," the Egyptian symbol of eternal life.

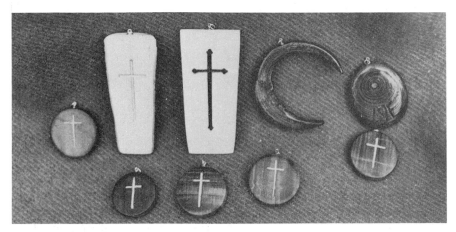

Fig. 28. These pendants are in holly, sumac, beefwood, and other African woods cut in 1½-in (4-cm) cross-grain disks and polished. Most have veiner-incised crosses tinted with gilt. The moon pendant, though, has a whittled face.

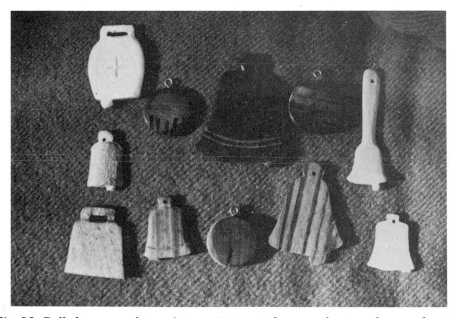

Fig. 29. Bell shapes can be made in various woods as pendants or they can be strung together to form a garland. They were made from scraps ⅛ to ¼ in (3.2 to 6.3 mm) thick and from such woods as purpleheart, bubinga, vermilion, embuya, zebra mahogany, walnut, bass and holly.

Fig. 30. Some ideas for Christmas pendants.

*Fig. 31. Tiny gnomes like this were whittled from vermilion. Carved in very **hard** woods, such pendants require no finish except neutral shoe polish or wax; the knife lines are allowed to remain. A Santa Claus figure would be quite similar.*

CHAPTER VII

Remaking a Gothic Altar

OLDER CHRISTIAN CHURCHES, particularly in Europe, may be Baroque or Romanesque in architectural style, but the generally accepted architecture and interior decoration in older American churches is Gothic. But Gothic itself is a class rather than a single style; there were many interpreters as the centuries passed. Thus, if you plan to produce something as an interior appurtenance to a Gothic-style church, it is advisable to study the church itself and compare it to the standards, so that your work will be fitting. One problem of many churches is that they are a mixture of styles because various priests, ministers and contributors through the years have not done their homework. There are many excellent books on the Gothic style, so it is inadvisable to attempt to capsulize the subject here.

Like most carvers, I have on occasion been asked to produce something for a church. Most such projects are relatively simple, but one I encountered several years ago was not, at least initially. It had to do with a Jesuit retreat house that had been converted from an elaborate private mansion built between 1910 and 1920.

Because of changes in the Mass, Catholic churches and chapels have been installing what is called a portable altar in front of the main altar, so the priest can face the congregation. Most such altars are built in, and are not portable at all, and many are modern—not in keeping with the interior design of the church itself, nor with that of the high altar behind them. In this case, the priest in charge wanted a truly portable altar, so it could be moved to other rooms of the house as the need arose, yet one that would primarily be in keeping with the design of the Chapel. Any altar I could design that suited the room was far beyond the budget, so we toured the building for a piece of furniture that might possibly be converted. We found a credenza made in Belgium around the turn of the century, Gothic in style and much the worse for wear, with some of the carved tracery missing. However, it had been made in oak and was assembled with pegs, so could be rebuilt readily. Rather surprisingly, also, when we tried it in the Chapel, it fitted before the altar

exactly, its chamfered corners even matching a similar chamfer in the marble floor!

My idea was to fill in with panelling behind the traceried three front sides and to reverse the very good linen-fold panels in the back so they would be visible from the rear. (These panels were set in grooves in the framing.) This would create a cabinet inside, accessible through two of the rear panels, in which accessories for the altar and the Mass could be carried when the altar itself was moved on casters. Fortunately, both the top and the bottom shelves were in good condition.

The first job was to rebuild the credenza, largely a matter of repegging with ¼-in (6.3-mm) maple dowels. This involved some juggling, because the open front had to be backed by ¼-in (6.3-mm) oak-faced panelling (six pieces) screwed in place, which had to be done as opportunity offered, before the back panels were all reset. The two end panels in the back were recut to fit as doors to be swung on piano hinges. Final assembly included installing the piano hinges through the door opening itself; there was no other access. Feet were also drilled to accept ball casters. There were seven feet to be leveled; two required the addition of an oak plate to replace deteriorated wood.

I detail these steps because none involved woodcarving, yet were essential preliminaries, as frequently happens in carving. When assembly was completed, I found that two tracery corners were missing, as well as elements of the lower border trim. These were carved from ½-in (12.7-mm) oak to match the others and set in place with toe nails through drilled holes. Unsightly joints in back where the rear legs met the top were covered with triangular bosses of ½-in (12.7-mm) oak, carved to match the other tracery. The altar was a memorial, so I also made a pair of cartouches of 1-in (25.4-mm) oak, lettering one with the name of the man for whom the altar was a memorial and the other with an appropriate sentiment provided by the priest. These were centered on the outer corner panels. Lettering was simple incising of V-grooves, done with a knife.

At this point, I had the altar stripped and refinished professionally, so all wood, whether old or new, had the same dark color, to match the panelling of the Chapel. Then gilt paint was added on the lettering, and the job was done.

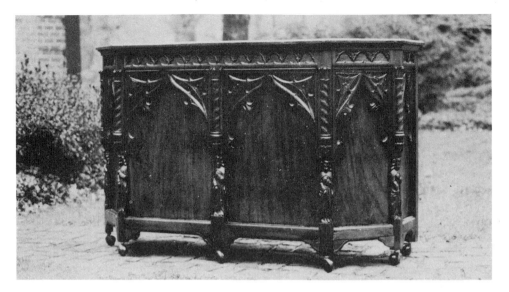

Fig. 32. The finished altar, about 20 × 80 in (50 × 204 cm).

Fig. 33. The linen-fold panels which had formed the rear wall of the credenza had been thinned to ¼ in (6.3 mm) on the edges to fit the grooves in the framing. Thus they could be reversed to decorate the back. Two were made smaller to become piano-hinged doors closing against framing added inside, and bosses were added at the top outer ends to cover unsightly joints.

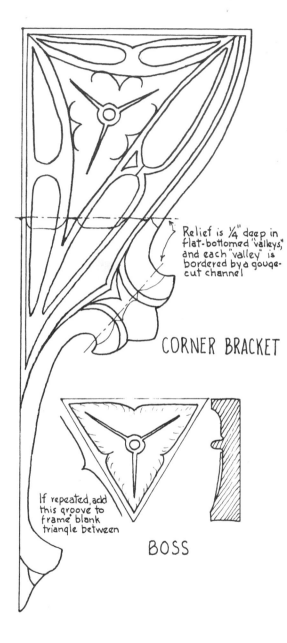

Relief is ¼" deep in flat-bottomed "valleys," and each "valley" is bordered by a gouge-cut channel

CORNER BRACKET

If repeated, add this groove to 'frame' blank triangle between

BOSS

Figs. 34–35. (Left) Sketches of a corner bracket and boss. (Above) Matching cartouches of 1-in (2.5-cm) oak—about ¾ in (19 mm) finished—were centered in the corner panels. Lettering was incised with a knife and touched up with gilt after finishing.

CHAPTER VIII

Holy Figures of Medieval Europe

A few examples of masterpieces by Riemenschneider, Stoss, and others

MAN HAS ALWAYS bent his best efforts to worshipping his gods, so some older shrines and churches of the world are treasure houses of exquisite woodcarvings, some of them centuries old. Because the church spanned the centuries and had the funds to pay for the work, the best sculptors and carvers were hired to produce masterpieces for worship and decoration. Also, because the church was less likely to be wantonly destroyed, many of these works have been accumulated and preserved. Thus we find magnificent woodcarvings in Japan, China, the Near East, and in Europe. However, as a result of the Protestant Reformation and the rise of Puritanism, some of the finest woodcarvings were destroyed or defaced, particularly in England.

In the Catholic countries of Europe we find the most familiar carvings, ranging from Christ on the Cross to statues of the Virgin and the saints to very elaborate Stations of the Cross and retablos, the latter usually in high relief. Much of this was finished by polychroming and gilding, so was done in relatively soft woods like linden (similar to our basswood), and became more and more ornate as the centuries passed. Indeed, the great sculptors such as Michelangelo, Dürer, Riemenschneider, Stöss, and Gibbons did much of their work in such woods, and often devoted enormous amounts of time to detailing hair and draperies. I have sketched here a few examples of this work, but any effort to be inclusive would require a library. Indeed, most libraries have volumes with pictures of the better-known examples of the work of the masters, although such books tend to feature a limited number of sources and sculptors.

The current increase in woodcarving for churches in the United States has generated a similar increase in the demand for patterns. Because in many cases the demand is for traditional figures and designs, it is usually advisable to base a modern design on a traditional one. The cleric who seeks more modern designs for the traditional figures is still rare, however.

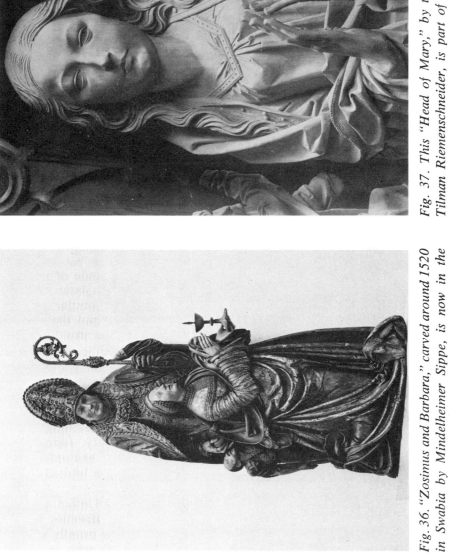

Fig. 37. This "Head of Mary," by the German master Tilman Riemenschneider, is part of the Marienaltar in the Holy God Church, Creglingen on the Tauber. Again, note the detail in the hands and robe.

Fig. 36. "Zosimus and Barbara," carved around 1520 in Swabia by Mindelheimer Sippe, is now in the Nuremberg Museum. Note the detail of robes, faces and hands.

Fig. 38. Veit Stöss is famed for many altars. Here is a close-up of a high-relief section of his Christmas Altar in Bonn.

In general, the modern approach is to strip much of the detail from a design and to avoid the garish painting and gilding. Robes tend to be simple and free-flowing, hair simulated rather than detailed (and the intricate curling locks of Medieval figures abandoned for straight hair). Also, faces are less ascetic or pained. The costuming also is more nearly that of Biblical times and places than that of the European locale of the church or carver, and the very high relief of that period is replaced by low relief with possible tinting of the background to set off the figures. Indeed, several carvers I know have been asked to replace overly strained faces or overly graphic

injuries, or to produce figures with features like those of the parishioners. Thus we commonly see Nativity scenes with figures having Indian, black or white faces and features rather than Semitic ones. Also, the lack of polychroming has required designs with stronger lines, more light and shadow, even silhouetting of panels to show the scene clearly.

For any given figure, there are endless variations. For example, the Crucifixion normally depicts an emaciated Christ, but I have sketched a Michelangelo design (Fig. 41) that depicts a very robust one. Normally, also, the arms are stretched widely on the crossbar, but some representations, like one by Stöss, for example, have the figure sagging, with the arms coming down at a fairly steep angle. It seems to be traditional for His head to be turned to His right and His torso to sag to the left, however, although occasional carvings have His head sunken straight forward. During the recent visit of the Pope to New York, one Crucifix showed Christ with His right arm detached and reaching down to the people to help. So there *can* be variations even in so traditional a subject.

Figs. 39–40. Two close-ups of sections of Riemenschneider's Marienaltar: (left) Jesus with Andrew, and (right) another saint.

CRUCIFIXION - Michelangelo
For Vittoria Colonna. From a
sketch in the British Museum.
More robust, less ascetic, than usual.
No crown of thorns. Varied hands.

Fig. 41.

HEAD of CHRIST on the CROSS - Stöss
Holy Ghost Hosp., Nürnberg. Some
thorns missing. Note hair detailing.

CHRIST'S HAND
Veit Stöss. St. Sebald's
Church, Nürnberg.
(Rotated 100°)

Fig. 42.

Fig. 43.

This chapter provides only a general survey; there are other examples of figures throughout this volume, including one chapter on draping alone (see Chapter X). Certain elements should be particularly stressed, however. The face, hands and feet are extremely important in all of these carvings because they must portray the emotion and the situation. Thus Medieval carvers became adept at carving the human face in agony or wonder. The male face was usually elaborately bearded, with curly hair, and somewhat thin, while the female was very rounded and chubby—somewhat "pretty" rather than strong and realistic. One continuing problem, in fact, is that the Madonna and Child is often more nearly a girl and a younger boy: Her figure is too immature and His too·mature. In the absence of any definitive portraits of any of the early saints, these are distinguished by their appurtenances or the context. (Some of these distinctions are shown in the panel of symbology, pages 26–29.)

While in-the-round figures tended to be life-size, much of the high-relief was in panels of reasonable size, and some of it in miniature. There was, of course, a great deal of more conventional decoration, including doors, bosses on beam ends, screens in archways, pulpits and the like. Gibbons, who carved in England after the Reformation, was a devotee of floral swags, for example; St. Paul's has a choir stall full of them. These could have been in a country house as well as a church; there is nothing particularly religious about them.

CHAPTER IX

Modern Stations of the Cross

Two modern approaches to tradition, one stressing hands, the other faces

THE WAY OF THE CROSS IS FAMILIAR in Catholic, Anglican and some other churches. It is a series of stations, originally nine but now usually fourteen, each depicting an incident in Christ's passion (trial and crucifixion). Each has a particular office to be said at it, and it may consist of a picture, an image or simply a number within a church or shrine, or a walkway leading to it. In older churches, particularly in Germany, the stations were elaborate high-relief carvings of scenes. Many modern churches have simple panels, sometimes with a phrase or Roman numerals, on the wall. In the Salt Cathedral, outside Bogotá, Colombia, for example, the stations are 40-in (1-m) gilded Roman numerals of wood, lighted from behind.

Several sculptors have recently designed simpler, low-relief stations. Two sets, both by professional sculptors, are shown here (Figs. 44–57). One is a series in which hands alone are used, designed and executed by Eleanor Bruegel of Broomall, Pennsylvania, at the suggestion of Mons. Richard J. Simons, pastor of St. Anastasia Church, Newtown Square, Pennsylvania. Each is a single piece of $1 \times 7\frac{1}{4} \times 10\frac{1}{2}$-in ($2.5 \times 18 \times 27$-cm) white pine in the form of a squat Cross, painted with clear oil stain that was tinted a dark ultramarine blue to contrast with the white walls of the chapel in which they are hung. The hands were left natural color; the wood of the Cross (where it is shown) was stained a dark wood color; fabrics were tinted appropriately. Ms. Bruegel doesn't generally approve of color, but felt it necessary in this case to make the stations stand out. She also does not recommend pine particularly; it tends to warp and split in dry heat and wide temperature variations. The stations, while modern in concept, are realistic depictions, so were acceptable to older parishioners as well as younger ones. In fact, two of the originals (XI and XII) were stolen and had to be replaced—a compli-

ment of sorts. Ms. Bruegel, a graduate of Skidmore College, worked for seven years in Oberammergau.

The second series, for Christ Episcopal Church, Pompton Lakes, New Jersey, was carved by Michael DeNike of Wayne, New Jersey, and was executed in 3 × 12 × 16-in (7.5 × 30 × 41-cm) cherry, assembled from narrower planks. They were finished without tinting to bring out the rich honey color of the wood. To facilitate a consistency in the face of Jesus, a cardboard profile was cut and re-used with necessary changes of expression made in each sketch. Mr. DeNike, a childhood whittler, has had training in several schools, and now operates the American Carving School.

Both carvers point out that their sketches were primarily blocking guides; they developed detail in the carvings themselves.

The Stations of the Cross

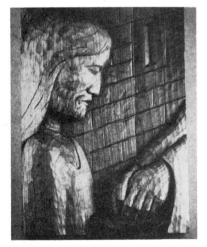

I Jesus before Pilate, who washes his hands

II Jesus takes up the Cross

III Jesus falls for the first time

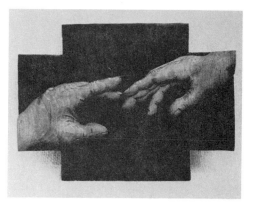

IV Jesus meets His Mother

V Jesus helped by Simon of Cyrene

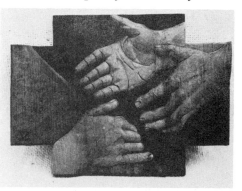

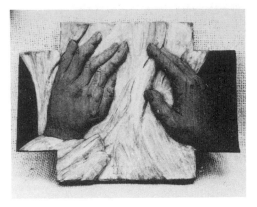

VI Veronica wipes Jesus' face

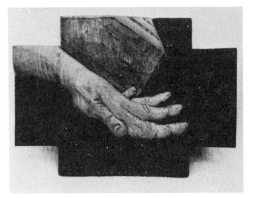

VII Jesus falls a second time

VIII Jesus meets the women of
Jerusalem

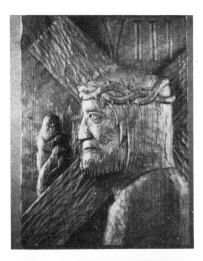

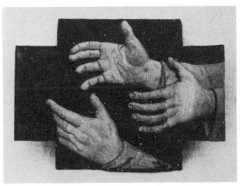

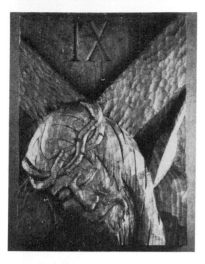

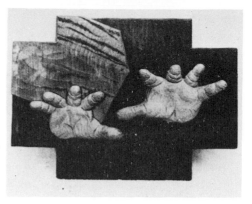

IX Jesus falls a third time

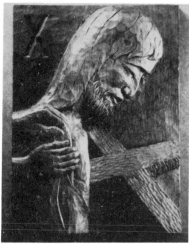

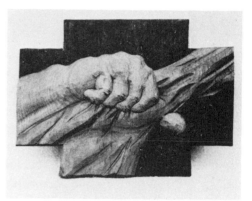

X Jesus stripped of His garments

XI Jesus nailed to the Cross

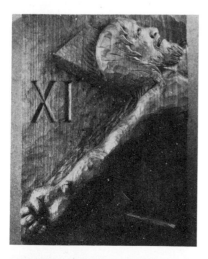

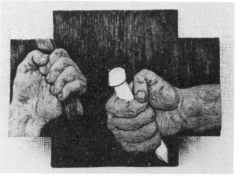

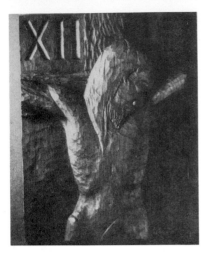

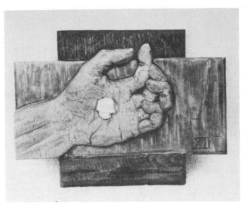

XII Jesus dies on the cross

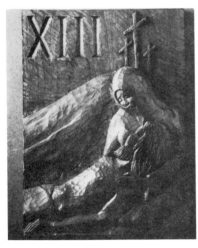

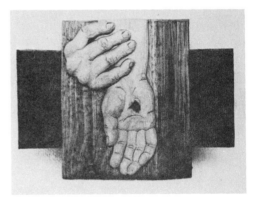

XIII Jesus taken down from the Cross

XIV Jesus laid in the tomb

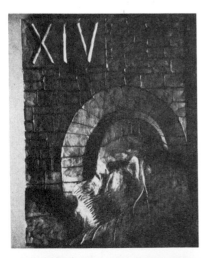

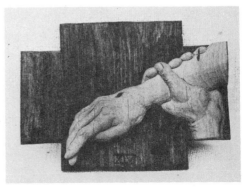

CHAPTER X

Draping the Figure

GOTHIC ART, WHICH SUCCEEDED ROMANESQUE and was in turn succeeded by the Renaissance, was particularly evident in church architecture, and in fact has continued to be the expected form in Christian churches. It is characterized by the pointed arch, high vaulted areas, delicate tracery, forms based on the clover (trefoil), and the breaking up of window areas into small panes. There was also Gothic sculpture, which broke away from classical Greek and Roman tradition and originally had a great deal of freedom. It originated in northern Europe, and was strongly developed in Italy, particularly in interior decoration and sculpted figures. Thus we find Italian wood sculptors doing work in Germany and Spain as well as in their own country, and foreign sculptors coming to Italy for training, so that figures of saints all seem to have a similar look.

The draping of Christian figures has become almost standardized. We expect to see them in fairly long and flowing robes, regardless of their sex, and with the robes apparently of thick and stiff material so that it falls into heavy folds. Originally, in earlier periods, these robes, often richly ornamented, simply flowed down from a fairly stiff figure, but as the centuries passed, the carvings became action poses, with the same heavy drapes swirling about them. Michelangelo was a major influence in this change, and is still the model for liturgical sculpture.

This effect is difficult to obtain by posing a model; it is usually better to utilize a conventional design with the desired drapery flow. As you will readily see in the group of sculptures pictured here, a considerable feeling of action and life can be obtained by the design of the robing, even though it is more stylized or conventionalized than realistic. Any major church, particularly the older European ones, will provide similar examples.

There are two problems in carving such draperies. First is the ever-present problem of working from the outside in, as a woodcarver must. It is essential to allow enough wood for the deep folds. This leads to the second problem: the necessity of having some knowledge of anatomy, so that the folds will

Fig. 59. "Saint Mark," again by Berruguete. He is shown writing his book; the lion symbol is at his feet. Note the elaborate swirl and draping of his robe.

Fig. 58. "Judith With the Severed Head of Holofernes," by Berruguete. According to the Bible, she delivered Jerusalem by going to Holofernes' camp during a siege, and cutting off his head when he was drunk.

come in proper locations, and their lower surfaces will suggest the form of the body under them.

Among the best of Spanish sculptors was Alonso Berruguete (1488–1561), who was employed for his entire life by the royal family, after he returned from thirteen years in Florence (1504–17). His work has the tense, contorted style developed by Michelangelo, a sinuous form that suggests spiritual agony. Included here are a number of closeups (Figs. 58 and 59) of the backs of choir stalls in the Catedral de Toledo, all in walnut, done by Berruguete, who carved the entire interior in both wood and stone.

Fig. 60. Conventional treatment of female attire is typified by this 6-in (15-cm) Virgin in ivory. It was carved in the 13th century and now resides in the Museo Lázaro in Madrid.

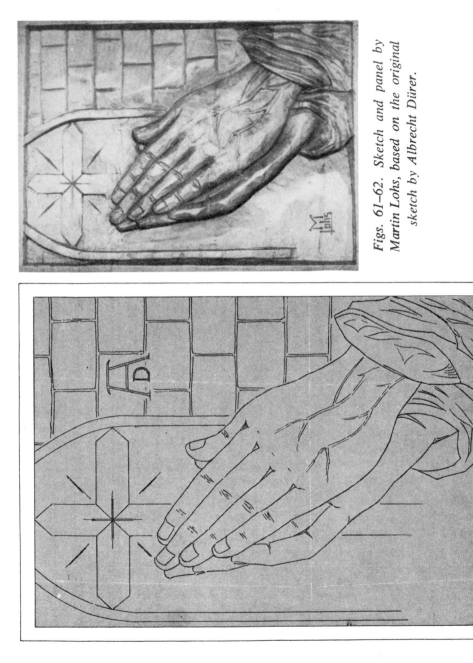

Figs. 61–62. Sketch and panel by Martin Lohs, based on the original sketch by Albrecht Dürer.

CHAPTER XI

The Praying Hands

Dürer's famed sketch comes to life in wood

BETTER KNOWN THAN ANY SUBJECT in the Western World, except the Nativity, is Albrecht Dürer's (1471–1528) famous "Praying Hands." The hands have been copied commercially in drawings, sketches, and paintings in various media; as plastic, plaster, china, wood-composition, and wood panels or wall decorations—perhaps even in brass and cast iron at various times. But, paradoxically, Dürer himself never incorporated them in any of his famous woodcuts! The *Betende Hande* was only a sketch.

Hands are extremely difficult to carve well, and this 475-year-old design will provide excellent practice. Martin Lohs, Cincinnati, who made the copy-sketch and panel pictured (Figs. 61 and 62), says of them: "Hands are one part of the anatomy which must be brought to life as you work them, otherwise they will look like a pair of gloves. Take a careful look at your own hands while you carve this pattern. Note the difference in thickness in the fingers between the joints . . . try to get the wrinkles at the joints as you see them in your own hands." Mr. Lohs has carved this subject numerous times, improvising a different background each time (Dürer's sketch had no background). The hands can, of course, be carved without a background; these are practically in-the-round, anyway. They were carved in maple, but can be carved just as readily in pine or basswood. The work was stained to add character and shading.

CHAPTER XII

Today Interprets Yesterday

GEORG KEILHOFER IS A BAVARIAN who came to the United States in 1967 as a professional woodcarver for the Schnitzelbank Shop in Frankenmuth, Michigan. He has conducted classes and done commissions for a variety of clients ever since. His classes are unusual in that students continue year after year, doing the projects of their choice rather than following a set curriculum. Some have come weekly from considerable distances—as much as 250–400 miles.

Mr. Keilhofer is the son of a professional carver who had difficulty finding work after Hitler came to power and who later died in the war. Georg intended to become a violinist, but had to join his mother in making doll furniture after his father died. He entered apprenticeship at the crafts school in Berchtesgaden at 14, and had two additional years of cabinetmaking there after he completed the 4-year apprenticeship. His first work consisted of making small Madonnas and similar figures, largely with a knife rather than with chisels. He is still an advocate of the tools and mallet—no power equipment, and no sanding—but his work is marked by such careful finishing with the tools that sanding would be an abomination. He is, however, a strong advocate of preliminary modelling in clay rather than depending upon sketches, and does much of his own work without references beyond the original sketch.

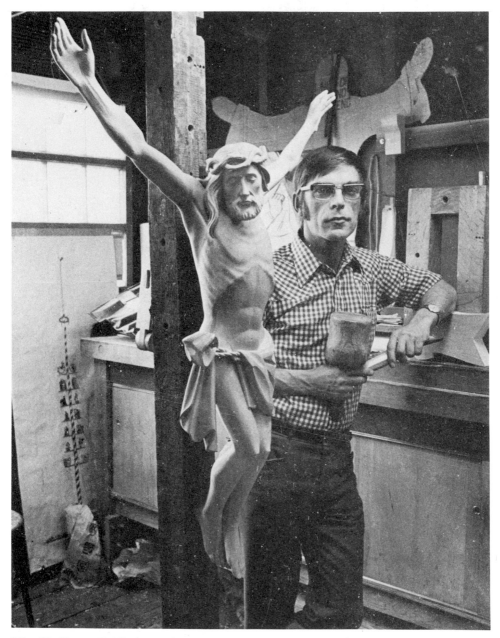

Fig. 63. Georg Keilhofer with a 4-ft (1.2-m) Christ made of basswood. It is laminated, and the arms were made separately, with grain running the length of the arm to provide greater strength in hands and fingers.

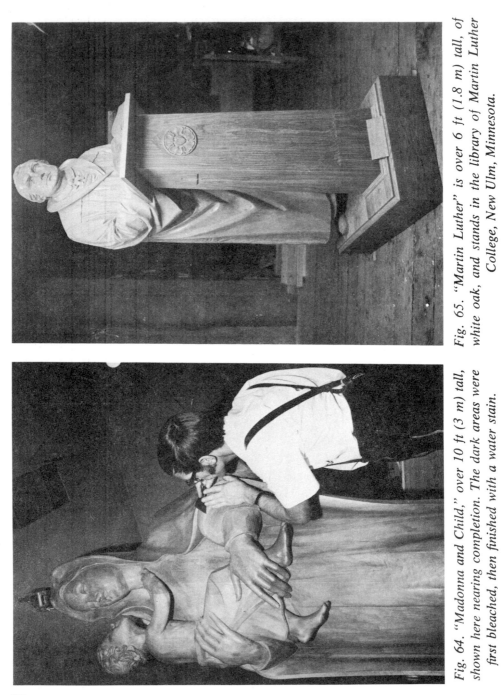

Fig. 64. "Madonna and Child," over 10 ft (3 m) tall, shown here nearing completion. The dark areas were first bleached, then finished with a water stain.

Fig. 65. "Martin Luther" is over 6 ft (1.8 m) tall, of white oak, and stands in the library of Martin Luther College, New Ulm, Minnesota.

CHAPTER XIII

An Ethnic Nativity

High accuracy and quality mark modern depiction

AN INCREASING NUMBER OF LITURGICAL CARVINGS are abandoning traditional forms and draperies, and depict instead persons of a local ethnic group, in order to become more accessible to parishioners. This makes a lot of sense, particularly in the case of the Nativity scene, which was originally developed by St. Francis of Assisi to convey the story of Christ to largely illiterate Italian peasants in his congregation.

The Good Shepherd Mission, Pinehaven, New Mexico, was dedicated in June, 1975, in Navajo country. Shortly thereafter, Sister Mary Francesco Irmen issued an invitation, with rough sketches, for a Nativity set featuring Southwestern Indians. Eleanor Bruegel, of Broomall, Pennsylvania (see Chapter IX for another example of her work), submitted sketches and won the commission.

The first group, completed in 1977, includes the Holy Family and a Shepherd carved as Navajos. They are in basswood, with Joseph (standing) about 12 in (30 cm) tall. A year later she added the Three Wise Men: an Iroquois bringing wampum, a Chippewa with a blanket, and a Sioux with a peace pipe. Other figures and animals will be added later. Figures are finished with a colored oil stain. (It should be pointed out that the Indians of the Southwest and Mexico believe that the Three Wise Men bring Christmas gifts —as related in the Bible—rather than Santa Claus.) Profiles of the Wise Men show the high quality and detail of Ms. Bruegel's execution, as well as the authenticity of her depictions.

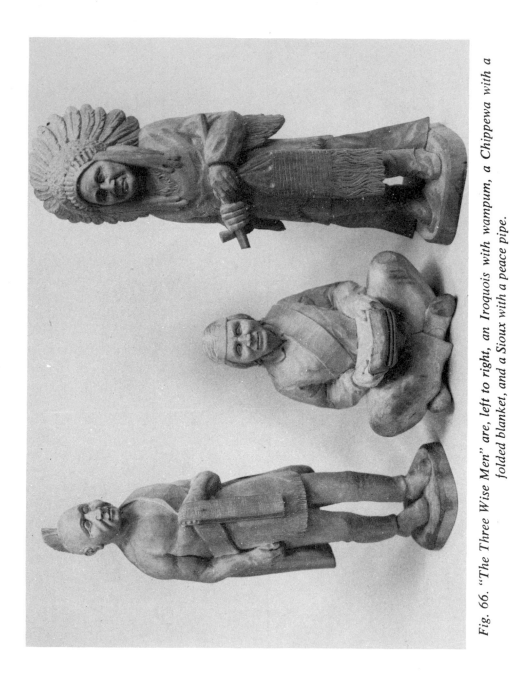

Fig. 66. "The Three Wise Men" are, left to right, an Iroquois with wampum, a Chippewa with a folded blanket, and a Sioux with a peace pipe.

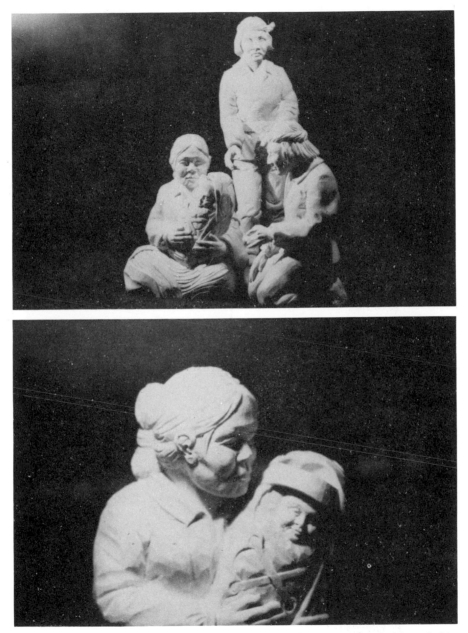

Figs. 67–68. (Top) The Holy Family, with a kneeling shepherd and his lamb; (bottom) Mary and Child.

CHAPTER XIV

Santos – America's Medieval Art

DON JUAN DE ONATE, WITH 130 MEN, took formal possession of New Mexico for Spain in 1598. By 1640, a chain of 50 missions had been established from Socorro in the south up to Taos, supported triennially by a caravan of 30 wagonloads of supplies coming up 1,700 barren miles from Mexico. There were also settlements, small communal villages complete in themselves, but barely sustaining life with their flocks of sheep. In contrast to Texas and California, New Mexico was arid and non-productive, and so became a neglected stepchild of Spain.

As a result of this isolation, the area around Santa Fe and Taos maintained a medieval approach to religious expression until about 1900. Zebulon Pike rediscovered the settlements there in 1806, but nothing was done about them,

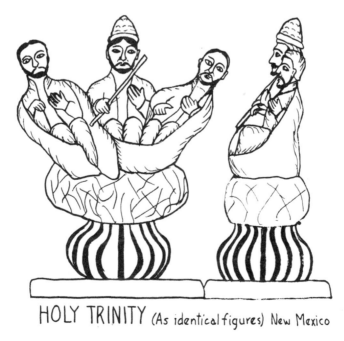

Fig. 69.

HOLY TRINITY (As identical figures) New Mexico

practically speaking, from the time of Mexico's independence until New Mexico became a state.

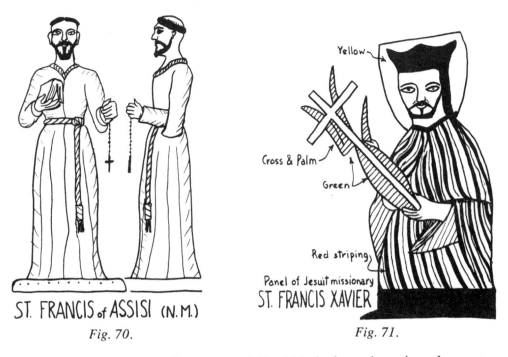

ST. FRANCIS of ASSISI (N.M.)

Fig. 70.

Yellow

Cross & Palm

Green

Red striping

Panel of Jesuit missionary
ST. FRANCIS XAVIER

Fig. 71.

In this isolated atmosphere, a specialized kind of wood carving, the *santo*, was born and developed. *Santos* were small household woodcarvings of saints, who were rewarded for their help or punished for their neglect by being turned face to the wall or put away in chests for a time. They were taken out to arid fields to enlist their aid in getting rain and were rewarded when rain came. As they wore out, they were replaced by new ones carved by local *santeros*. The patron chose the subject, but the *santero* interpreted the commission. He was an honored folk artist, and he copied existing *bultos* and *retablos* (statues and altar screens) as well as he was able, interpreting as he went.

Subjects could be the Holy Family, an archangel, St. Francis, St. Isidore (the farmer), saints in the Franciscan order, Santiago (St. James the Elder or St. James of Campostello). Santiago had been the patron saint of the Spanish against the Moors, and his name was invoked by both Cortes and Alvarez when they beat the Aztecs, as well as by Onate when he beat the Indians at Acoma. So the Indians adopted this powerful ally, calling for his

85

help against even such modern conquerors as Pancho Villa. They still dance in his honor each year. He is usually represented as a man on horseback, wearing a tall black hat and brandishing a sword.

About a dozen *santeros* did much of the carving and are identifiable by some distinguishing mark, the pose of a head, the cast of the features, a border detail. Much of their work is gone now, but some examples are still extant in museums and private collections. The usual wood was cottonwood, covered with homemade gesso and painted with garish watercolors. I have sketched four typical examples and indicated the colors. You may find it enjoyable to try figures with such a long and unusual history—true American folk art dating much farther back in its antecedents than most of what we are doing now.

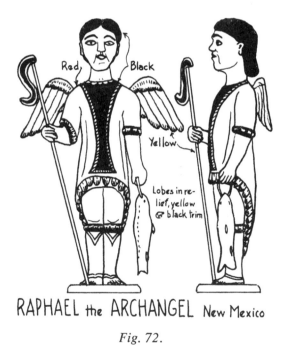

RAPHAEL the ARCHANGEL New Mexico

Fig. 72.

CHAPTER XV

Miniatures May Be Ivory

Portable votive pieces are often very detailed

WE TEND TO THINK OF RELIGIOUS CARVINGS as large and almost overpowering, with many of the figures heroic in size. However, a great many carvings are small and some even miniatures, most of the latter being done in ivory. All of the cathedrals of Europe have such treasures in the form of altarpieces, crosses, candleholders, monstrances and the like.

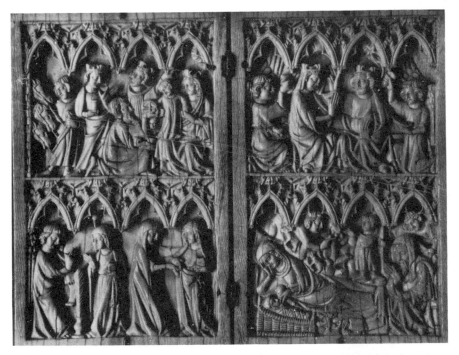

Fig. 73. Stump figures about four heads tall characterize this diptych in ivory, presently in the Museo Lázaro, Madrid. It dates from the 14th century and is in the so-called School of Paris style.

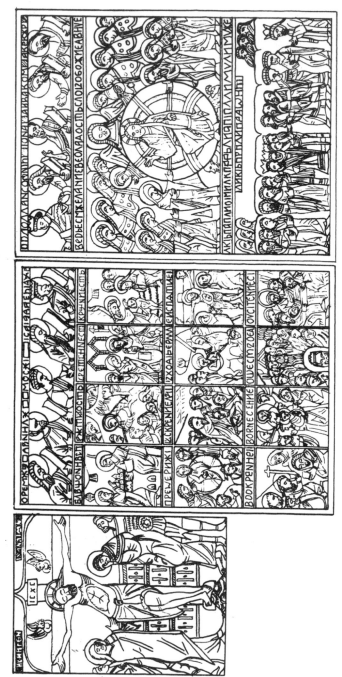

Fig. 74. Both the diptych and triptych are common in miniature religious art. This diptych, at present in the Kremlin collection in Moscow, is only 2¾ × 3½ in (7 × 9 cm) when closed, including the wooden framing, yet contains multiple scenes so detailed that a photograph, unless greatly enlarged, would not show them clearly. The interior panels (center and right) are entitled, respectively, "Twelve Feast Days," and "Praise the Lord."

Figs. 75–76. This Italian polyptych (left) in ivory dates from the 14th century. The ivory is tinted and the background antiqued. The triple triptych (right) is a retablo behind an altar in Vienna's Stephansdom. Top and bottom triptychs are wooden frames with painted scenes.

In modern churches, the tendency seems to be to combine wood with glass or tile or metal, rather than ivory—perhaps an indication of the growing scarcity of ivory. Highly decorative crosses are particularly in favor, and the woods involved are usually the best of the hardwoods, which provide the basic shape, with the metal, glass or mosaic forming rays, aurae or inlays.

I have provided only a limited number of examples here; art and liturgical books will provide more familiar examples, and most museums have pieces as well, because a great many of the miniature pieces were made originally for family chapels or to be worn by an individual. An example of the latter is the ivory pectoral icon from the Kremlin, which I've sketched (Fig. 74) because a photograph, unless it is very large, fails to show the tremendous detail incorporated. This icon is a folding diptych (2-part panel) framed in wood and with a crucifixion panel on the closed front face.

Two of the other altarpieces pictured are also in ivory, one with color tinting (Fig. 75). This one is unusual in that it has side panels which also fold, so the "doors" close as a box around the bowed central panel. The larger one from Vienna (Fig. 76) is really a triple triptych, in that side panels close over three separate sections individually. The top and bottom triptychs are primarily paintings, and the central triptych is very heavily polychromed and gilded.

CHAPTER XVI

The Seats of the Godly

Medieval misericords show some startling subjects

DURING MEDIEVAL TIMES, clerics could sit or kneel during most regular services, but were required to stand during the Divine Office—and the Divine Office went on interminably throughout the day and night: matins, lauds, tierce, sext, and so on. Choir seats were folded back during them all, so it was hard on older or infirm clerics.

Late in the 11th century, some aching cleric devised a subterfuge, a little ledge on the bottom of the seat, functional only when the seat was up, invisible when it was down. Thus a priest could appear to be standing while he was actually resting his aching buttocks on the ledge. The idea spread like wildfire over western Europe; the ledges were soon being installed everywhere. They had the general shape of half an inverted cone about 6 in (15 cm) across the base, and were justified as an indulgence in the rigid sacerdotal rule about standing. Hence they came to be known as misericords, from *misericordia*, the word for mercy.

As time went on, misericords were often carved out of the block of the seat itself, to give the ledge support strength. The carvers among the brothers

Making & Tapping Wine or Beer Glutton

Fig. 77.

were tempted, and soon the misericord area beneath the ledge was being decorated with flowers, crude monsters, even human heads—anything that wasn't scriptural—because it was obviously improper, disrespectful and irreverent to put the form of Jesus, Mary or an Apostle there. Hence the secular subjects, amplified as the good brothers hired or required lay woodcarvers to do some of the work.

Here the explanations diverge. Some sources I've read say that the monks and priests themselves took liberties, or permitted them, in the subjects and treatments; others say it was the lay carvers, drawing upon the life about them, who did so. The latter explanation seems dubious to me, because lay carvers had no reason to be other than circumspect in their work, while some of the clergy might well have rebelled against the strictures of their existence, then as now. What's more, they were the educated men of their time, with the only precise knowledge of morality—and immorality—such as it was.

Fig. 78.

Suffice it to say that misericords included the widest range of subjects in church art, ranging from work in the field and in the trades to eating, drinking, domestic scenes, sleeping, amusements, games, dancing, contests, swordplay, wise sayings and foolish acts, monsters, even love and sex. I have seen pictures of somewhat improper elements worked into the elaborate carving of rood screens and the like in English churches, but the misericords are

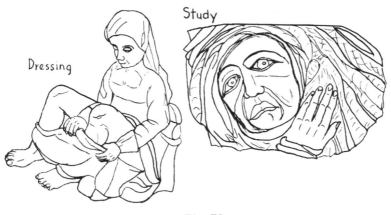

Dressing

Study

Fig. 79.

Birching a brat

Glutton

Fig. 80.

smaller and the subjects therefore more simple and specific. In any case, later clerics felt impelled to mutilate some of the more suggestive or specific subjects. In 1787, the Archbishop of Paris issued a decree calling for the destruction of the "bizarre and singular" figures in the choir stalls at St. Martin de Champeaux. Instead, the chapter painted them ocher, and thus saved them so that they are visible today. In other churches, subjects like a couple sharing a bath or an apothecary administering a clyster to a woman were defaced, and selective effacement was used on a group of tumblers with exposed genitals. In other cases, angel heads and similar innocuous subjects were substituted or carved over the originals.

Even in modern times, clerics have been apologetic about the medieval

misericords in their churches, so that many have disappeared on one pretext or another. However, there are upwards of 8,000 in existence in French churches alone. The only ones in Paris are at St. Gervais, including a Seine boatman, a shoemaker, an architect, and a wine wholesaler. (These stalls were carved in the 16th century, when guilds were strong in church support.) The miner sketched here (Fig. 78) is on a choirstall seat in Tréguier, Brittany. The sleeping monk (Fig. 78) at Notre Dame in Prey is a surprisingly modern treatment. Even more skilled is the study of a head, also sketched (Fig. 79). It is formal and very fluid for 500 years ago.

Most misericords were in oak or chestnut and were rarely colored. They simply glowed in their own natural color and subject, in hiding below the choirstall seats, which were not limited to the clergy, but were often occupied on a regular basis and endowed by royalty, titled people and affluent church-men. Then , as now, only commoners were banned from the high seats.

CHAPTER XVII

Sudden Sculptures

Israeli examples show the trend to machine carving

IT IS NO COINCIDENCE that most of these pieces—practically all, in fact—are from Israel. While it is obvious that highly developed countries would be using available mechanical aids, just as we did some years ago when we adopted profilers for making components for carved furniture, it is surprising to see it in a developing country. I have found widespread use of production machinery only in foreign countries that make large numbers of wood carvings for the tourist trade.

In Oberammergau, Germany, a high percentage of the larger carvings (most of them traditional religious figures and panels) are roughed out to within ⅛ in (3.2 mm) or so of finished dimensions on profilers at a central roughing factory, then distributed to the various woodcarving shops. So, too, in Israel, where factories in small towns around Jerusalem and Caesarea use power equipment, including profilers, sanders and power saws of various types. The size of the industry in Israel is, in fact, surprising, because of the shortage of suitable wood and the assumption that other crafts would dominate. However, every tourist shop seems to have olive-wood carvings for sale, most of them only hand-finished. Most are also religious in character—and Christian, at that. It is unusual, also, that most of the pieces are small, catering to the low-budget tourist in particular.

The most popular subjects are those relating to the Nativity, such as crèches, the Magi, the Holy Family, Madonna and Child, and camels in every imaginable pose. Many of the shops in the Arab souks of Jerusalem sell obviously factory-made carvings, but display a lathe, some tools and a floor full of shavings in their windows to suggest authentic hand manufacture to the unwary tourist.

There are, of course, hand-carved pieces made by individuals, but many of these are also made with the aid of power equipment because it is the only way in which the carver can compete. Avigdor Bezalel, who works alone making jointed panels and attenuated figures of thin olive wood, uses a

flexible-shaft machine and a bandsaw, as well as a drill, a jigsaw and a power sander. Even so, he is converting his attenuated figures to bronze, using his originals as patterns. He explains that demand and price force him to do it, the same statement made by shop owners in Oberammergau.

His jointed panels, such as the two of Jerusalem impressions shown here (Figs. 81 and 82) are designed for machine production. The components are sawed out on a bandsaw, then detailed with cutters. One touch of a wheel cutter makes a window, a small circular saw outlines a building, and so on. Only the tinting is by hand, but this is particularly important in creating the effect he seeks—that of stone buildings of various styles built on a hillside. Surprisingly, they *look* like Jerusalem and are quite dramatic against a light wall or even a window. The components are assembled with copper-wire loops or leather thongs.

He also makes a series of attenuated figures in thin pine, tinting them grey and rubbing the edges to get an antique effect. Included are a full set of signs of the zodiac and a dozen or more domestic scenes, of which I have shown three (Figs. 83, 84, and 85). The fact that he uses thin wood also makes his work unusual, although he does have problems with the tendency of olive to warp when taken from the local atmosphere. This factor should be considered if you plan similar pieces. Also, olive wood has a positive "figure," which on occasion can interfere with the detail of the carving. This, plus knots and other flaws in the wood, results in pieces which will appeal to the tourist but make a woodcarver cringe.

A simple barrette (not shown) is made in a factory and is one of a number of designs produced in the cheapest possible way—parts being sawed out and glued together to avoid any problems with lowering the ground and smoothing it. The decoration is done with a veiner and consists of simple lines.

Similar in technique are a number of designs made in shell, most of them quite crude and obviously carved with flexible-shaft machines, then glued into a scene, usually the Nativity. However, there are also pendants of nacre, with pierce-carved designs, and expertly finished. It is a fair assumption that the pendants are made by the more highly skilled workmen, because the components of even the elaborate Nativity scenes are sawed and detailed very crudely. Yet, at a little distance, they are easily recognizable and very effective because of the "glow" of the nacre. Details are only outlined, not modelled, so the reflectivity of the flat surface is interrupted only by essential lines—the piece is like a pencil sketch without shading. These pieces are

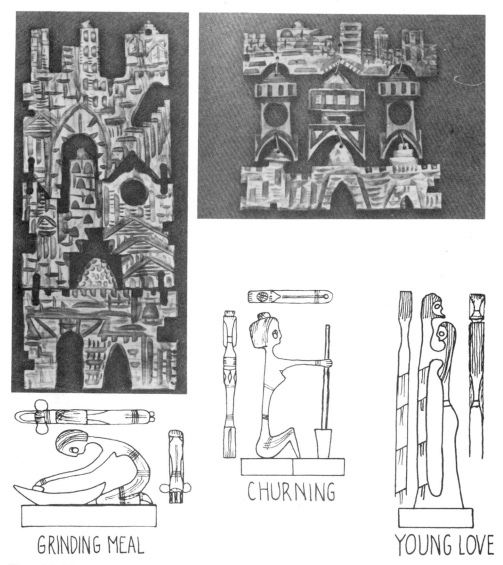

GRINDING MEAL CHURNING YOUNG LOVE

Figs. 81–85. Avigdor Bezalel is representative of the modern Israeli wood sculptor forced into mass production in order to compete in the market. The photographs show two of his studies of Jerusalem. The one at top left is composed of three segments joined by thongs; the surface decoration was limited to simple fluter and gouge cuts and tinting. The one at top right has two long panels joined to three vertical sections with wire loops. Bezalel has also developed attenuated sculptures in thin wood, illustrated here by sketches of three of his domestic scenes.

97

reminiscent, somehow, of the miniature crèches and crucifixion scenes made in Oberammergau, in which effects were obtained by bold planes rather than detailed modelling of figures. Somehow, the observer's eye and brain corrects these flaws, perhaps because of the familiarity of the scene.

I was also very much impressed with the possibilities for carving in wood the miniature figures made in brass by Teppich in Jerusalem (as shown in Fig. 86). A surprising variety of personalities is obtained with a simple, turned shape, the identification being obtained by headdress, arm position, and details of decoration. The forms are apparently turned, smoothed, and lacquered black, then some further turning is done to return to the brass color; belts and robe trims are knurled, and the remainder of the detailing is done with an engraver's burin, including vertical lines. (In my sketches, I inverted the color for clarity; white sketch areas are black on the piece.) The maker has the advantage, of course, that there are no portraits existing of Biblical characters, so he can approximate the ethnic costume of the era. He has a dozen or more such figures, as well as complete chess sets. They could be made similarly in wood—about double the size shown—with arms of coated copper wire or bent plastic added, and details cut with a veiner into a stained or painted surface. There is an obvious trick in making them: leave a long base on the figure until the coating, polishing, and second circular cuts at least are finished, then cut off to the final base.

Many of the profiled figures—like the Holy Family, Moses' spies, and the Magi (Figs. 87, 90, and 91)—are quite detailed. All are single pieces, although there would be some temptation to make the uplifted arms of the spies separately, for example. Also, there is a great deal of veiner or V-tool texturing of areas, and the two spies differ in pose and dress. They carry the grape bunch on a reed, which, because of the position of the carrying hands, must be distorted; the assembly would be better and more realistic if the hands were higher so an almost straight rod could be used, although it should sag from the weight of the grapes.

The two versions of the Madonna and Child (Figs. 88 and 89) are amorphous shapes, but quite effective for that reason. They obviously require less hand work than the others. They and the classical bust (Fig. 92) are profiled on centers, so necessary circular shapes can be obtained, like the head basket on the mother, the overall bullet shape of the Madonna, and the base of the bust.

Another example of unique design is carved avocado pits, which have grotesque masks carved on them. They are made into pendants or key-ring ornaments, and are reminiscent of our carved peachstones and cherry pits.

Headdress is added bent sheet

Arms are bent wires in holes, with ends flattened & shaped into hands

Side view of JOSEPH

JOSHUA

ABRAHAM

SARAH

Head is cut off & reset

Beard is flat added sheet

Twisted-wire shepherd's crook added

Original figures are this size, in brass, by Teppich, Jerusalem. They are laquered gloss black, then decorated by engraving to base metal.

Front view of HASSID

Side view of DAVID

SHULAMITE

Fig. 86. Several brass sculptures by Teppich. They are lathe-turned, black-coated, and then the features and decoration are cut through the gloss finish to reveal the base metal. Bent-wire arms help to avoid a rigid look, as does the figure attenuation at the top.

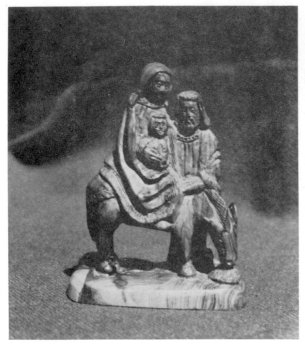

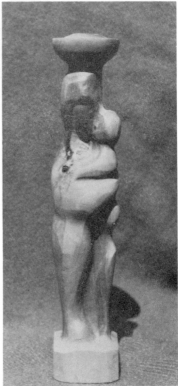

Figs. 87–89. Clockwise from top left: "The Flight Into Egypt," a traditional design in olive wood, is about 6½ in (16.5 cm) tall and of one piece; these two versions of the Madonna and Child can be produced on a profiling lathe with almost no finishing except sanding.

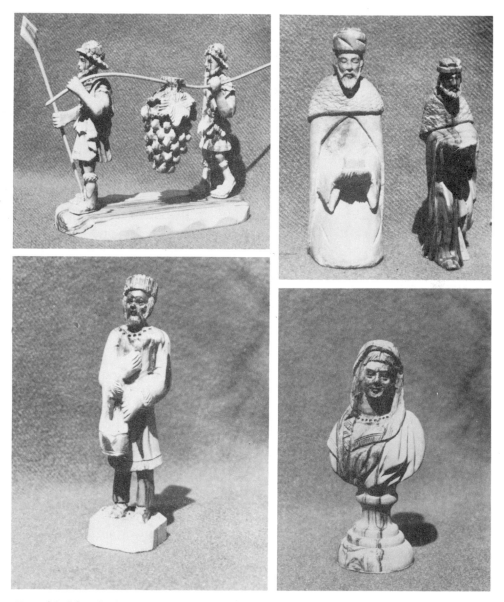

Figs. 90–93. Clockwise from top left: Moses' spies returning from Canaan; two Magi; a classical bust; and a portrait of a Russian serf. Detailing of the features and decoration, as well as definition of hair, must be done by hand, of course

They can be made more easily with a hand grinder or flexible-shaft machine than with a knife. However, the avocado pit, like the cherry pit, requires less attention to surface pattern than does the corrugated surface of a peachstone.

It is interesting to note that most modern countries producing woodcarvings favor three-dimensional subjects. Israel, the Scandinavian countries, Switzerland, Germany and Japan are examples, as is the United States. (In a county-wide art show I recently judged, there were about 200 paintings, only 33 sculptures, of which just one was low-relief.) India, Ceylon (Sri Lanka), the Philippines and the Maori of New Zealand are examples of the cultures favoring relief carvings. However, countries as disparate as Bali and Germany make both in considerable volume, even though Bali, for example, must import wood to make them. Sometimes the available material dictates, as in the case of Israel or the Eskimos; sometimes it is the intended use, as in Europe several centuries ago, when most woodcarving was an element of furniture or wall decoration, or in New Zealand, where the Maori were decorating their council halls and canoes. Perhaps the paucity of modern relief carving is related to the scarcity and cost of wide pieces of suitable woods, as well as to the realization that it is much more difficult to do a good job with the third dimension severely reduced.

CHAPTER XVIII

Relief Panels with a Jerusalem Motif

JEWISH CONGREGATIONS HAVE BUILT many modern temples in recent years combining the traditions of their faith with newer decorative forms, particularly in wood. These examples were designed and carved by Gardner Wood, of Albert Wood & Five Sons, Port Washington, New York, who has executed a number of such commissions. The two illustrated here are quite interesting because they show how a given design motif may be adapted to varied forms. They are in Temple Sinai, Dresher, Pennsylvania.

The central theme of both the panel and the doors is the City of Jerusalem. Both panel and doors are in basswood, the panel being finished with lacquer shellac and lightly tinted butcher's waxes. The double-door panels, on the other hand, were gold-leafed over the entire face, then toned with various tints of a heavy paste called "Rub 'n Buff," which is available in 18 tones of brasses, bronzes, coppers and gold in many art-supply stores (made by American Art Clay Co., Inc., P.O. Box 68163, Indianapolis, Indiana, 46286). The paste will stick to any surface, and can be applied by rubbing or, thinned with turpentine, by brush in difficult areas. Mr. Wood says he can texture a surface with tools or gesso, for example, before applying the paste, and can apply various tones over each other to get special effects. The more the surface is rubbed, the better the finish gets. On pieces likely to be handled, such as the doors, he spray-coats the finished surface with polyurethane gloss varnish.

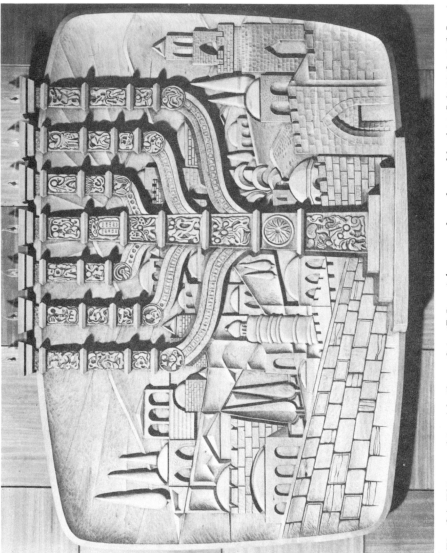

Fig. 94. This panel is of built-up 3-in (7.5-cm) basswood, and roughly 4 × 5 ft (1.2 × 1.5 m) in dimension. Relief is only about 1 in (2.5 cm) deep, but antiquing creates the effect of depth. The menorah is electrified with "flutter" bulbs.

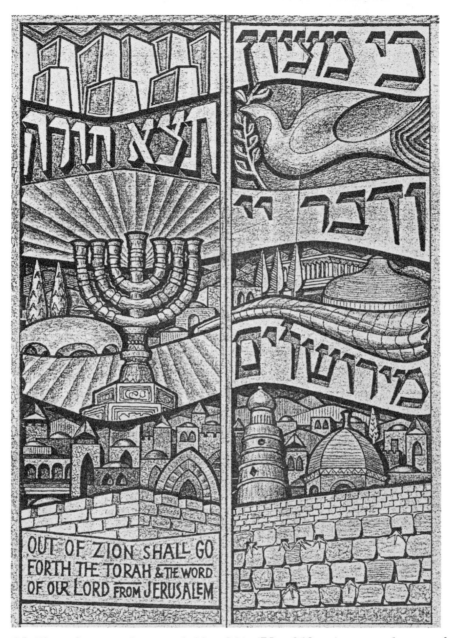

כי מציון

ודבר יי

מירושלים

תצא תורה

OUT OF ZION SHALL GO
FORTH THE TORAH & THE WORD
OF OUR LORD FROM JERUSALEM

Fig. 95. These door panels are each 30 × 84 in (75 × 213 cm), mounted on standard plywood doors. The series of views of Jerusalem includes the Wailing Wall at lower right, the old walled city at lower left, the Knesset building and Memorial at center, and modern apartment buildings at upper left. Carving depth is only about 1½ in (4 cm) at most.

CHAPTER XIX

Primitive Religious Art

Often almost crude, reflecting mixed origins

THE TYPICAL MEXICAN OR CENTRAL AMERICAN PEASANT is deeply religious and has combined some of his pre-Columbian religion with Catholicism. Thus, many carved figures may be derived basically from those in Spanish-inspired churches, but many others are an adaptation or combination. Some are frankly pagan, or quite different in concept from our ideas—such as the frequent designs for Satan or for mystical gods seen in ruins or described in ancient myths. All through Central America and in the more remote areas of South America, the sources of carvers' ideas are similarly mixed. In

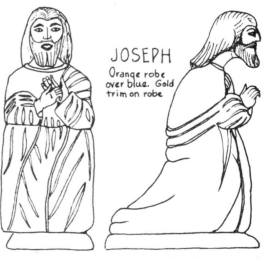

JOSEPH
Orange robe
over blue. Gold
trim on robe

Fig. 96. "Kneeling Joseph," by Miguel Jimenez, from near Oaxaca, Mexico, who describes himself as a toymaker despite his world-wide reputation. This figure is about 12 in (30 cm) tall, in copal, and painted with brilliant colors.

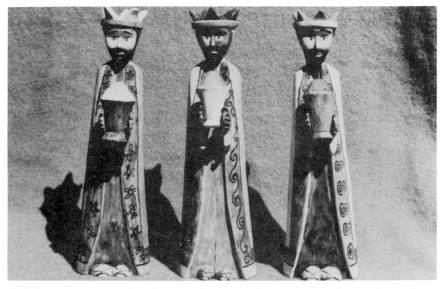

Fig. 97. "The Three Kings," one of many Mexican variations. These three are basically the same figure, with separately carved arms holding a bowl, chalice, or chest.

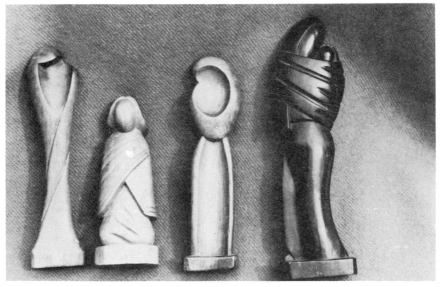

Fig. 98. Three Madonnas and an orant, typical of the very modern Ecuadorian designs. They vary in amount of detail as well as in pose, but they are unmistakable. See also Fig. 99.

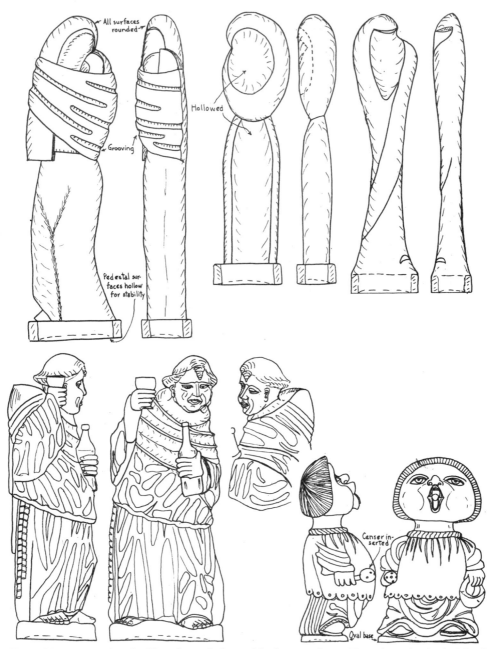

Figs. 99–100. (Above) Sketches of three Madonnas from Ecuador. (Below) Much more sophisticated Ecuadorian carvings are these of a bibulous monk and an acolyte, both in mahogany. See also Fig. 103.

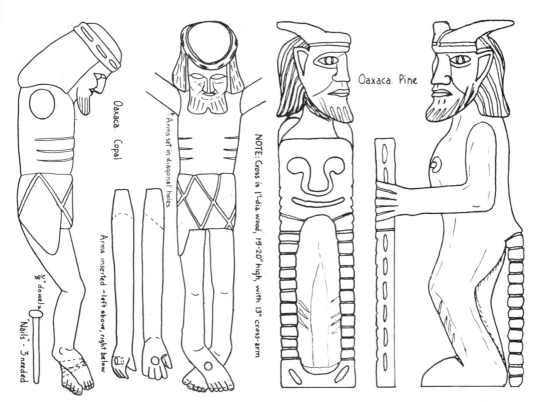

Figs. 101–102. *A simple and dramatic "Christus" (left) from San Martin Tilcajete, Mexico. It is of copal and was done by a farmer in his spare time. The arms were separately carved and inserted, and the nails are separately whittled pegs. "Satan," (right) as conceived by a Mexican farmer who also worked in a suggestion of a skeleton. See also Fig. 103.*

Europe, many religious carvings are copies of originals hundreds of years old, and are rather crude in execution by modern standards.

In contrast, in countries in which a great deal of carving is done, such as Italy, Switzerland, Germany and Ecuador, the religious figures tend to be quite sophisticated; many show an effort to transcend traditional styles. I have endeavored here to show a variety of designs from several countries, although the basis is largely contrast between the primitive Mexican and much more sophisticated Ecuadorian pieces.

Certain religious concepts capture the imagination of primitive carvers, so we find the Madonna and Child, Christ on the Cross, Satan, the Three Kings and the Virgin to be particularly common. Carvings may either be in-the-round or silhouette panels designed for wall hanging, and tend to be in softer

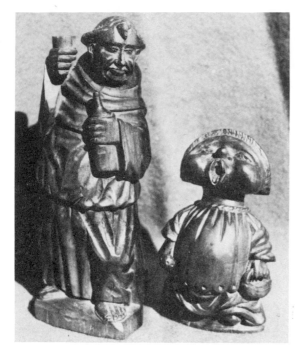

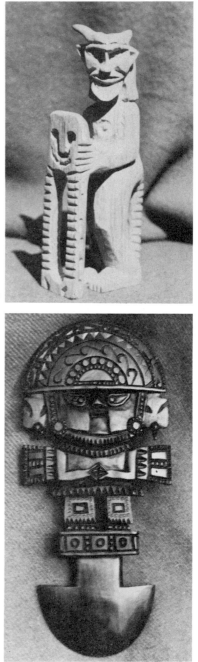

Figs. 103–105. Clockwise from top left: Ecuadorian monk and acolyte; Mexican "Satan"; and "Tumi," or ceremonial axe, from Peru. The latter is not a Christian symbol, of course, but is probably at least as old.

woods and painted in garish colors, often made from local plants. They may be as much as 6 ft (1.8 m) tall, and usually are full-figure; the bust is a more sophisticated concept. Legs may be short and the entire figure disproportioned, particularly kneeling figures. Also, larger figures may be assembled—arms on the Christus, wings on angels (one larger angel has the wings nailed to a spring-steel strip so that they tremble), etc. The Three Kings may be basically the same shape, with forearms holding urn or chalice or inserted jewel chest, and slight changes in crown and beard (Fig. 97).

FRIAR Spain Antiqued

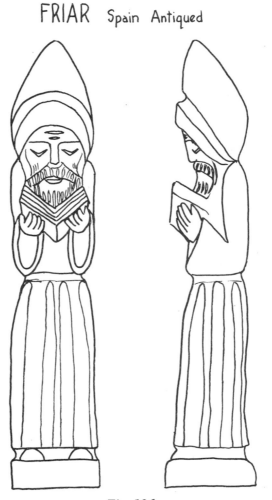

Fig. 106.

Many of these carvings do not conform to the western world's traditions of liturgical art, and indeed may not have proper proportions or be perfectly executed, but they are strong and powerful and they serve the local people well. They convey the carver's reverence and piety, while many more sophisticated carvings do not. With greater sophistication often comes a tendency to be inhibited in design or execution, and traditional in idea. This is not true, apparently, in Ecuador, where there seems to have been an increasing tendency to avoid rigid detailing of faces and hands, for example, and a tendency to make a design pleasing to the eye, and to have a flow or motion so that its parts emerge naturally, one from the other.

Nativity scenes and the like now are built up of very simple figures, with strong planes replacing the usual meticulous detail of robes and hair arrangement. The result is work that conveys its message swiftly and without distracting detail. A similar thing was done in Oberammergau some years back, particularly on miniatures of the Crucifixion, the Last Supper, and the like, a complete scene made to fit into a walnut shell. To the observer, the scene appeared to be meticulously detailed and was not the least confusing—perhaps because the silhouettes were so familiar—but on close examination the individual figures proved to be largely slivers of wood with only major planes and silhouettes carved. It was dramatic, effective, and simple, something which many carvings are not, to their detriment.

Fig. 107. An "Obeah" plaque from Haiti, carved in mahogany; it is about 8 × 16 in (20 × 40 cm). Obeah, which we call "voodoo," is a serious religion in Haiti, based on African roots, and has produced some unusual carvings.

Maori – Best in the Pacific Islands

LIKE ALL POLYNESIANS, the Maori were deeply religious and expressed their beliefs in profuse woodcarvings. They were, however, unusual even among Polynesians for their elaborate style, which is quite distinctive and probably the result of centuries of isolation. Their carving is considered the best of that of any of the Pacific islands.

The Maori are thought to have migrated from "Hawaiki" (Tahiti, in the Society Islands) in three great migrations, the first in the 10th century and the last about 1350. They originally carved with tools of greenstone, and apparently developed their distinctive style quite quickly, perhaps partly because wood deteriorates rapidly and because the house and possessions of a dead man were considered taboo and left to decay. Thus, carvers were continually making new pieces, many of them architectural, for houses and canoes. Panel work was stressed. The Maori carver was considered of priestly rank and gifted by the gods, so was highly respected in his community. He washed his hands before and after carving, never blew the chips away because that was considered sacrilegious, and undoubtedly followed the same practice as the Africans in begging the pardon of the tree for cutting it. His work area was considered contaminated by the presence of women, fire or cooked food.

All this ritual was undoubtedly a factor in building excellence, because the carver was competing not only with his fellows, but for the further favors of the gods. When the first white men came, during the 16th century, carving was already at its peak. The Maori, however, readily accepted Christianity, with the inevitable result that their belief in their own gods declined, and the quality of their work began to suffer as well. By the 18th century, the work was becoming more rococo and less original. The introduction of steel tools early in the 19th century brought greater crispness, incisiveness and speed to carving, but apparently did not halt the decline in quality and quantity. During the 19th century, in fact, carving in some areas disappeared entirely.

In recent years, despite Maori and government attempts to revive the art, it has continued its decline. Establishment of a Maori school of carving

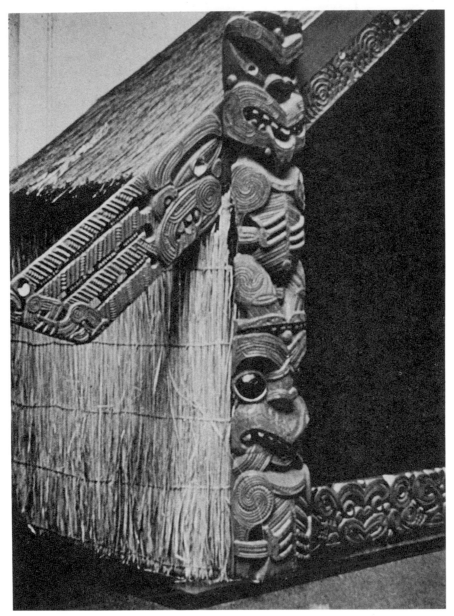

Fig. 108. Details of a "pataka," or storehouse, trim, showing a pillar, part of the threshold, and part of the barge board. This was carved in the Maori carving school according to traditional designs. The open front will be closed with elaborate vertical panels.

seemed to help for a time, but this now has difficulty finding apprentices. The Maori enjoy full enfranchisement in New Zealand, and many are quite wealthy because of their ownership of land and natural resources like hot springs, so the economic scale is high and carving simply does not pay enough. Only when a village or some other group, or an individual, decides to undertake a major project, such as a council house, church, or memorial, is there any call for normal carving, and such calls are usually met by a skilled carver taking the contract and training his own assistants on the job.

A limited number of white men who are very interested in Maori history and traditions have taken up the art and, in most cases, do better and more authentic work than the Maori themselves—or so I found on a visit there. "Genuine" Maori carvings are turned out in one or two "factories" using modern cost-saving methods. They tend to be slapdash, simplified and blurred, and sell at high prices to tourists, of course.

Carving was so important to the Maori that they had their own legends about it. One is that it was originated by Rua, an ancestor of the aboriginal Ngo-Potiki tribe, who carved so well that he fooled the sea god into believing his work was alive. Rua is said to have bragged thereafter, "Nga mahi whakairo, nga mahi a Rua!" (The art of carving is the art of Rua!) A more likely story is that Rauru, son of Toi-kai-rakau (meaning "eater of wood," or in this case "carver of wood") came with his father c. 1150 and settled in Whakatane, where he originated the distinctive Maori style, as distinct from the Tahitian or Marquesan style of his father.

Maori carving is different in that it features spirals, particularly double, 3-way and 4-way ones, a unique element. It also consists mostly of panels; in-the-round figures are comparatively rare, used primarily for peak ornaments on roofs, for base decorations on pillars and posts, and sometimes on canoe prows. (Many apparently 3D figures are really two-sided, pierced panels.) A third distinction is the featuring of paua-shell (like abalone) inserts for eyes and other decorative spots. A fourth is the preoccupation with the human figure and the development of a figure with flexed (bent), or folded and often undersized legs, a rounded belly, and three-fingered hands over it. (Other models included fish, birds, lizards, the dog and the rat, plus a few legendary concoctions; there were no larger animals in New Zealand at that time.) The Maori developed a language of the tongue in symbols and spiral tattooing which their carvings reflect. Their favorite wood was totara (*Podocarpus totara*), although others were used on occasion. Carved structures were common, including gateways, house beams, lintels and pillars,

115

Fig. 109. "Manaia" forms grouped in a panel by Austin Brasell, of New Zealand. These are common background motifs, usually secondary to a principal figure depicting an ancestor. The panel is in "pinus radiata," originally a California tree but now common in the South Pacific, and its dimensions are 15¾ × 15¾ in (40 × 40 cm).

canoe prows, war and ceremonial clubs—all heavily religious and concerned with ancestor worship. Pierced-work panels were common, and were very lacy and light.

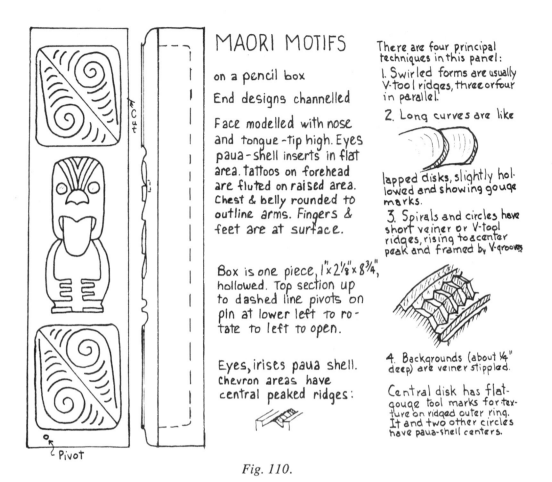

MAORI MOTIFS

on a pencil box

End designs channelled

Face modelled with nose and tongue-tip high. Eyes paua-shell inserts in flat area. tattoos on forehead are fluted on raised area. Chest & belly rounded to outline arms. Fingers & feet are at surface.

Box is one piece, 1"x 2⅛"x 8¾", hollowed. Top section up to dashed line pivots on pin at lower left to rotate to left to open.

Eyes, irises paua shell. Chevron areas have central peaked ridges:

There are four principal techniques in this panel:

1. Swirled forms are usually V-tool ridges, three or four in parallel.

2. Long curves are like lapped disks, slightly hollowed and showing gouge marks.

3. Spirals and circles have short veiner or V-tool ridges, rising to a center peak and framed by V-grooves

4. Backgrounds (about ¼" deep) are veiner stippled.

Central disk has flat-gouge tool marks for texture on ridged outer ring. It and two other circles have paua-shell centers.

Fig. 110.

Maori life was tribal, so villages were built around a central green (*marae*) on which was the meeting house (*whare whakairo*), which was also council chamber, guest house (for distinguished visitors only), and a sacred building. It was rectangular with a high, peaked roof and front porch, with the walls and roof extended around it. Such a building might be 15 to 40 ft (4.5 to 12 m) wide and 25 to 80 ft (7.5 to 24 m) long, with interior beams and posts carved and/or painted. A three-dimensional statue often stood at the front roof peak, surmounting a head. The ridgepole was considered to be the backbone for this head, and the rafters were ribs. On the outer front edge of the roof were elaborately carved bargeboards representing the arms of this

house spirit (hence the hand at the eaves), and they were supported at their outer ends by carved poles, often with three-dimensional figures at the base.

The handsome man was considered to be the one heavily tattooed and martial in bearing, proficient in the art of *haka*—the systematic distortion of the face and body to rhythm. So the grimacing face with protruding tongue, dilated eyes and defiant hands depicted in so many carvings is a portrait suggesting strength and virility. It was not intended as a caricature, although we might consider it as such. It is basically a matter of stylizing. The figure is quite commonly distorted, the face less so, although it may be elongated on occasion. I have drawn some examples, but for complete understanding of the many schools of Maori carving that developed, it is best to go to historical references; the space required takes a book of its own.

One further note: The most profusely carved building of the Maori was the *pataka*, an elevated storehouse set high on posts. Frequently, the entire front of such a building (which was like the council house in miniature, minus the porch) consisted of carved panels, plus elaborate bargeboards, pillars, and a threshold extending all along the front. Both bargeboards and threshold might incorporate pierced carving, as did canoe prows, bailing scoops (top only, of course), and ceremonial clubs. However, unlike the council house, which had its most elaborate carving inside, the *pataka* was carved only on the outside (see Fig. 108).

CHAPTER XXI

Hindu Figures of Bali

AS A WOODCARVER, I have on occasion been envious of the people of Asia and Africa, as well as of primitive tribes, whose idols and other religious symbols tend to be so much more colorful and imaginative than ours. Nowhere is this more evident than in Bali, whose people are both artistic and strongly religious. They are practically all Hindus, so that much of their carving depicts Rama and/or Siva and various legends concerning them, and some older pieces show demons, good and bad, priests and native gods and goddesses.

Some of the more fanciful pieces, now largely confined to the temples in each family compound, are extremely detailed, carved in softer woods and painted. Many, like the Garuda shown here (Fig. 113), are assembled, as are carved masks worn in dances depicting ancient fables, like the Barong (Fig. 111). More modern pieces are in harder woods, smaller, unpainted, and usually much less complex in detail. Again and again, however, the penchant for making attenuated faces and figures, like the rice goddess (Fig. 119) or the combined bust of Rama and his bride, Sita (Fig. 115), manifests itself, resulting in carvings that are extremely graceful, quite unusual, and attractive decorations for Western homes. Also, the dance masks and flat panels are extremely popular with Western collectors, and are quite unique.

In this group, selected to show as wide a range as possible, the holy man (Fig. 119) and the Garuda (a good demon symbolized by a male dancer dressed as a bird) are somewhat more formal than the others. The Garuda was assembled and is painted and gilded—just as Christian carvers finished their statues of saints in medieval times. Contrast, also, the good demon holding the child (Fig. 116) and the bad demon clutching a girl (Fig. 117). The latter is in the more elaborate older style of perhaps 40 years ago, while the good demon is quite modern and vastly simplified.

Carving pieces similar to these must be a painstaking operation in most cases, to avoid risk of breakage. The Balinese use small and thin tools and hold the work on their laps, so the shock of mallet blows is absorbed. Also,

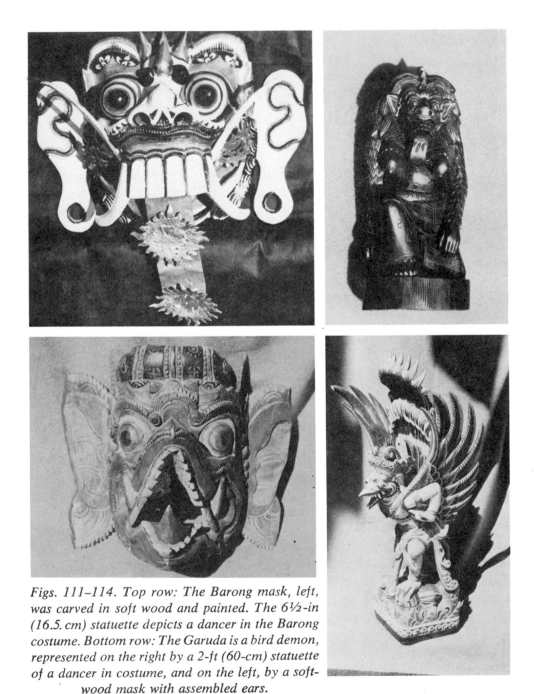

Figs. 111–114. Top row: The Barong mask, left, was carved in soft wood and painted. The 6½-in (16.5. cm) statuette depicts a dancer in the Barong costume. Bottom row: The Garuda is a bird demon, represented on the right by a 2-ft (60-cm) statuette of a dancer in costume, and on the left, by a soft-wood mask with assembled ears.

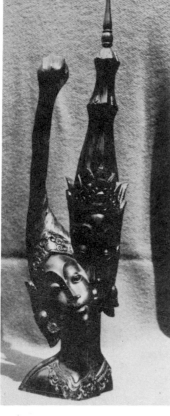

Fig. 115. Sita and Rama make an unusually graceful combination in Macassar ebony. The figure is 20 in (50 cm) tall, plus a 3½-in (9-cm) turned finial inserted in a drilled hole. Faces are stylized, and the elaborate detailing of headdresses and collars is even carried to the back.

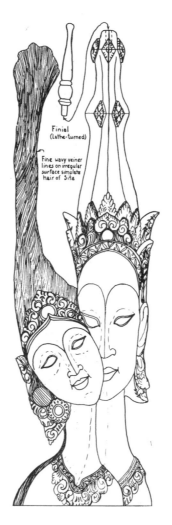

Finial
(Lathe-turned)

Fine wavy veiner
lines on irregular
surface simulate
hair of Sita

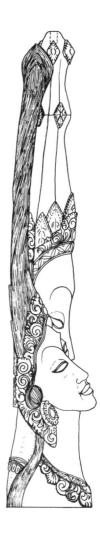

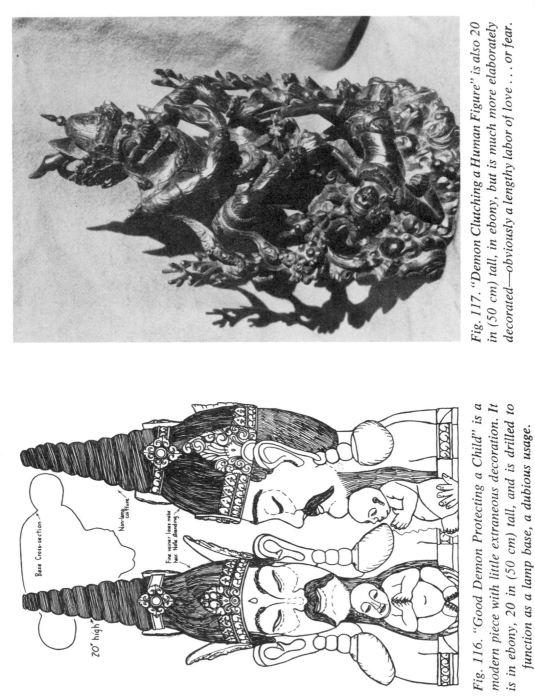

Fig. 117. "Demon Clutching a Human Figure" is also 20 in (50 cm) tall, in ebony, but is much more elaborately decorated—obviously a lengthy labor of love . . . or fear.

Fig. 116. "Good Demon Protecting a Child" is a modern piece with little extraneous decoration. It is in ebony, 20 in (50 cm) tall, and is drilled to function as a lamp base, a dubious usage.

Figs. 118–120. Clockwise from top left: "Holy Man," almost 18 in (45 cm) tall, is an old piece carved in soft wood and polychromed. His legs are folded in the lotus position and his beard and hair are stylized as a series of hemispherical bumps; "Priest" is in white wood and about 16 in (40 cm) tall. His torso is a compound curve, with right leg erect and the left leg flat on the ground; "Rice Goddess" is in ebony, 20 in (50 cm) tall, with shapely though attenuated arms and sinuous body. Her hair hangs naturally to join with buttocks for support, and hands touch neck for similar reason, but they create an effective closed design.

they tend to carve in very hard and dense woods like ebony, which can support the detail.

The Barong figure is particularly rich in detail and texturing, to simulate the elaborate costume worn by the man who dances this character. The skirt shows simple patterns made with small gouges (mainly a ⅛-in [3.2-mm] half-round), the blouse is cross-hatched, and fringe simulated with a veiner. This tool—of the smallest scope, about ½₂ in (1 mm)—also provides lines in the headdress, veins in the scales covering the arms, and hair lines in the outer robe. (This robe, in the actual costume, is mixed human and horse hair, put on in clumps to simulate and exaggerate a lion's mane, because the figure represents a lion god. He is supposedly sympathetic to humans, despite his fearsome appearance.) The method of simulating coarse hair is particularly noteworthy in this small ebony carving, only 6½ in (16 cm) tall.

It is interesting to compare the Barong face with the Barong mask (Figs. 111 and 112) which is full-size, or to compare the Garuda figure with the Garuda mask. There are enough resemblances to make each identifiable, but they show the range of interpretation of the same subject. Also compare the older-style holy man, stubby and old, with the modern priest, attenuated and achieving the yoga leg pose in a different way. Also, the older figure has a conventional base, while the modern one is done without a base. Note also the sinuous curve of the torso, an effect similar to that attained in the rice goddess, by lengthening and thinning the body. A similar effect is achieved in the bust combining Rama and Sita by lengthening the faces, particularly his, and carrying the hairdos very high. Also, the nose-eyebrow line is very prominent and high-arched, setting off the eyes in a frame.

CHAPTER XXII

Easter Island – Woodcarving Mecca

Traditional figures are mainly of gods and people, but unique

EASTER ISLAND IS UNIQUE in many respects: its isolation and relatively recent discovery by white men (1722), its gigantic stone statues, and the fact that the only present industry of the islanders (population about 1,800) is wood-carving. Paradoxically, this island, which actually consists of three volcanic cones joined by lava and soil to form a rough triangle 15 miles long by 8 miles wide (24 × 13 km), was stripped of most of its trees long before the woodcarvers came. Current demand for carvings requires the importation of expensive wood, so some carvers have gone to the Chilean mainland to work there.

Figs. 121–122. The Moai are miniatures of the giant stone statues found on the island. These two have decorated backs; the more elaborate one shows mountains, rainbow, two birdmen with egg, and other symbols of the late culture.

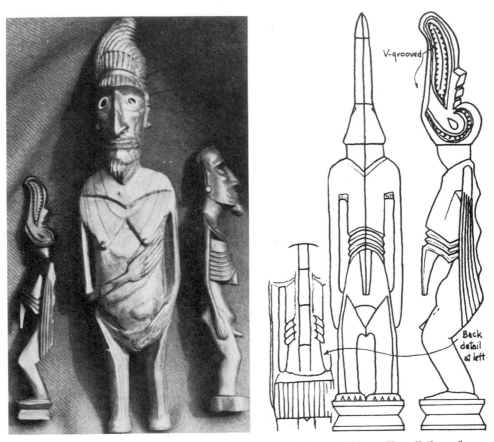

Figs. 123–124. "Birdman," "Wahine Moai" (goddess), and "Kava-Kava" (beneficent spirit)—in photo, left to right—are three of the more unusual figures. "Birdman," sketched at right, is a masked human from the later culture and represents the chief chosen annually.

V-grooved

Back detail at left

Although Easter Island has become a sort of tourist mecca, it is still visited by no more than 150 people a week during the tourist season, and has only two planes a week (from Santiago, Chile, to Tahiti), two shiploads of supplies a year, and occasional visits from yachts and tour ships. The island has no real port, so landing from ships is difficult. The economy is poor, so many natives will trade carvings for anything they can use, particularly clothing and cigarettes. However, the carvings are not especially cheap.

The island is a fascinating place, with much of mystery about it, because the first archaeological digging was done there only 20 years ago. There is a

great deal of natural beauty, many caves and vistas, but limited water in the dry season. The over 600 giant stone figures, which are world famous, were made in the past millenium, but the people who engineered them were wiped out in intertribal wars (except for one man), so the present population is Polynesian, plus the usual mixtures from passing ships. The builders of the stone images apparently came from the barren and rocky Chilean coast, and were white, with red hair! They made similar stone carvings in South America before migration, and their descendants continued them until they were wiped out in 1680. The woodcarvers of the island are the result of migrations from Polynesian and Marquesan islands where wood was plentiful.

Until very recently, almost all available carvings on Easter Island were copies of the giant stone heads and of smaller figures known to Westerners, but now unusual pieces appear occasionally, some of them original, some copies of pieces that have been hidden in family caves for a century or longer. Workmanship is of a high order, although tools are quite simple, and every possible scrap of wood is utilized. It is possible to visit some carvers; I was able to talk with, among others, Juan Haua, presently considered the best of the group.

Most carvers on Easter Island have very few tools: a knife, a small gouge or two of different sweeps, a V-tool and a veiner, for example. You can duplicate these carvings in the softer woods, sawing out the blanks with a coping saw. The common wood on Easter Island is acacia, yellow-brown, and most figure carvings are finished naturally with a low-gloss varnish and wax. The "talking boards" (Fig. 125) are, however, stained black. Eye inlays on the Wahine Moai (Fig. 123) are obsidian (black volcanic glass) in white shell, but can be duplicated with ebony in holly, or simply painted on the piece. In any case, you will have a figure quite unlike anything else your friends have seen.

Fig. 125. The two sides of the "Talking Board" (one side sketched here), are covered with hieroglyphics that have not yet been deciphered. A few such boards were found in family caves and apparently recorded song epics.

Index